>on screen>in time

transitions in motion graphic design
for film, television and new media

RotoVision

A RotoVision Book

Published and distributed by
RotoVision SA
Route Suisse 9
CH-1295 Mies
Switzerland

RotoVision SA
Sales & Production Office
Sheridan House
112/116A Western Road
Hove
East Sussex BN3 1DD
UK

Telephone
+44 (0) 1273 72 72 68
Facsimile
+44 (0) 1273 72 72 69
E-mail
sales@rotovision.com
www.rotovision.com

Book design by James A. Houff

Commissioned by Chris Foges
Edited by Erica ffrench

Printed by Midas, China

Separations by Hong Kong Scanner Arts

>on screen >in time

transitions in motion graphic design
for film, television and new media

Melanie Goux ◀▶ James A. Houff

The screen mimics the sky,

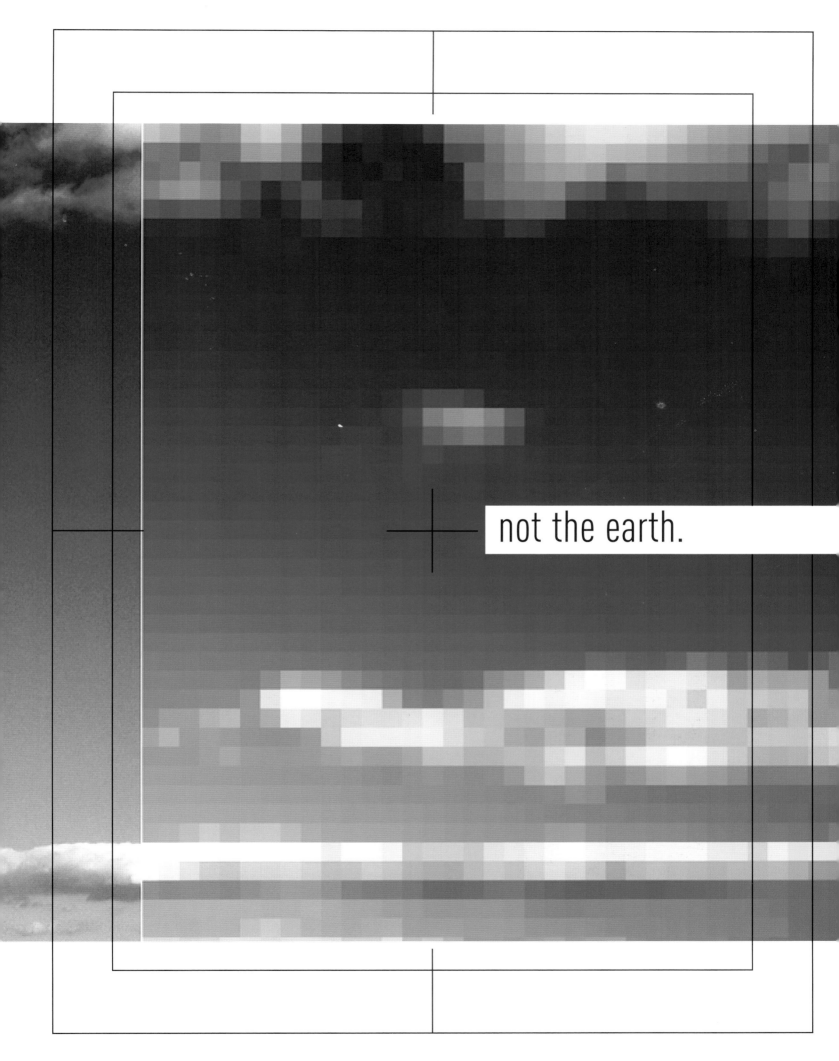

not the earth.

It bombards the eye with light instead of waiting to repay the gift of vision.

It is not simultaneously restful and lively, like a field full of flowers, or a face of a thinking human being, or a well-made typographic page.

And we read the screen the way we read the sky:

We look to it for clues ...

in quick sweeps, guessing at the weather from the changing shapes of clouds, or like astronomers, in magnified small bits, examining details.

Robert Bringhurst, 'The Elements of Typographic Style'
via: http://www.textism.com

>contents

>introduction

Few disciplines have the ability to capture both our attention and imagination as effectively as motion graphic design. Few are as seductive to designers and viewers alike. Within this relatively new field, diverse disciplines converge to yield a variety of applications. Part advertising, entertainment, animation, videography, cinematography, editing, packaging, storytelling, art and craft, this medium may best be described, simply, as design of the moment.

At the core of motion graphic design lies the transition—images and text changing from one to another over time. Beyond the most basic temporal devices—such as dissolves, wipes, or cuts—there lies the more refined and thoughtful sleight of hand that pulls the viewer seamlessly from one part of the screen to another, or from one visual experience to the next.

Without exception, those featured in this book learned on the job. It is in that spirit that this book was created; as a casual exchange between mentor and student, a frank discussion between friend and colleague. In addition, most of the artists featured have either chosen to work alone or in small firms with fewer than ten

people. In our industry this has recently become the norm. Not so long ago, producing even the most rudimentary motion graphics required equipment expenditures in the hundreds of thousands of dollars, and operators with highly specialized skills. Firms had to grow large, to reach "critical mass" even to realize a modest return on their investment. Access to such production facilities was prohibitively expensive for individual designers, even when leased hourly.

These days, digital video production is mostly a desktop affair. Gone are the behemoth shops of the 1980s and 1990s. And gone too are the extravagant production budgets that once fueled them. Doing business by e-mail and telephone has replaced commercial travel, sales forces and client visits. Web postings have replaced lush, hand-illustrated storyboards carried under the arms of account executives. Small loft offices have replaced extravagant production facilities with trophy rooms. And desktop computers running consumer software have replaced massive refrigerated rooms filled with expensive, black, blinking boxes.

Generally speaking, most aspects of our field are now smaller, cheaper, faster and better. Without question, the companies most responsible for this fundamental shift are Apple Computer, Adobe Corporation and Sony. Together, these three companies have leveled the playing field and lowered the entry price to professional-quality, digital video production. Success is no longer available only to those with deep pockets. At long last, talent rules the day and many designers now enjoy an unprecedented level of creative autonomy, working alone or collaboratively, but in rooms of their own.

While recent advances in desktop systems have eliminated many barriers to production, these new tools are simply an extension of the technological flux that has always defined our craft. As designers in a technical medium, we routinely walk the fine line between technology and art in search of what is desirable over what is possible. One such development on the horizon is the international adoption of the MPEG-4 compression standard. More than just another compression scheme, MPEG-4 promises to be the first truly convergent standard. At long last, this

platform agnostic format will offer true interactivity and a vast range of applications, all of which will present new opportunities for design.

As our field segues from infancy to adolescence, the future is bright. More than ever, young designers, and those from other design disciplines, are gravitating toward motion graphics as the most challenging and exciting venue in which to realize their visions. In recent years, it has even become possible to study motion graphic design at many art colleges and universities throughout the world. In only the short span of twenty-five years, the craft has become recognized as a valuable and important field of design.

Perhaps the one organization that has been the most instrumental in calling attention and recognition to our work is the Broadcast Designer's Association (BDA). Over its twenty-five-year history, membership has grown from a few dozen participants in the USA to many thousands worldwide. Together with its sister organization, PROMAX, individuals from over sixty countries participate in annual design competitions and conferences held in eight major cities throughout the world. The BDA is an organization we have both been pleased to be associated with and we hope for its continued success.

When choosing participants for this book, we sought to find the broadest selection of designers possible. Therefore, those featured are of different ages, educational backgrounds, levels of expertise, and culture. Yet, however disparate they may seem, each shares an unmistakable passion and a unique talent for this type of work. Through interviews and images, we will explore the life and work of these sixteen highly regarded motion graphic designers. They are at the forefront of a new craft and as such are helping to reveal the potential of motion graphic design at the turn of the new century.

Melanie Goux
James A. Houff

1.

>progression

Matthias Zentner / Velvet Mediendesign / Munich, Germany

Shannon Davis / Turner Classic Movies / North America & Europe

David Carson / David Carson Design / New York, New York USA

The Designer's Republic / Sheffield, UK

Matthias Zentner / Velvet Mediendesign / Munich, Germany

There are those who specialize in fluent design and those who specialize in technical perfection. Mediendesign is one of only a handful of firms who excel in both. Generally speaking, their work is flawless and has often left me contemplating retirement. Although the future is difficult to predict, I believe it's safe to say when the history of broadcast design in the twentieth-century is written, Velvet will be more than a footnote.

Melanie Goux: Motion graphic design firms come and go, yet somehow Velvet has remained in the forefront since it was founded eight years ago. How have you managed to achieve this success?

Matthias Zentner: By setting high standards of quality for every piece of outgoing work, maintaining a passion for the work, practicing self criticism, ignoring trends, and avoiding redundancy. That is to say, never copy others, even yourself. Don't be vain either, instead, always try to serve the idea.

MG: How did you first become interested in broadcast design?

MZ: I came from a marketing and photography background and was always involved in picture tweaking. Then, I got a chance to work as a trailer editor for two years and became addicted to editing. Later, I moved on to become a Quantel Henry operator and later a Discreet Flame operator. When I first started in broadcast design, there was no name for the industry, and graphic designers working with motion were rare. This was primarily due to the equipment (what little there was) being limiting and complicated to operate. At the time, most motion graphics for television were still being produced on film using fifty-year-old techniques.

MG: What was your field of study in college?

MZ: Initially I studied engineering and economics. Because I missed creative work, I supplemented my

Project Title: Aspekte
Project Type: Program Open
Channel/Venue: ZDF Germany
Creative Director: Matthias Zentner
Director of Photography: Thorsten Lippstock
Producer: Stefan Müller
Art Director, Set: Frank Neumann
Art Director for Animation & Logo Design: Peter Pedall
Editor: Jochen Kraus
Animator: Peter Pedall, Hartwig Tesar
Compositor: Matthias Zentner, Andrea Bednarz
Music: Jochen Kraus
Software: Avid, Adobe AfterEffects, Quantel Editbox
Hardware: G4 Macintosh, Quantel

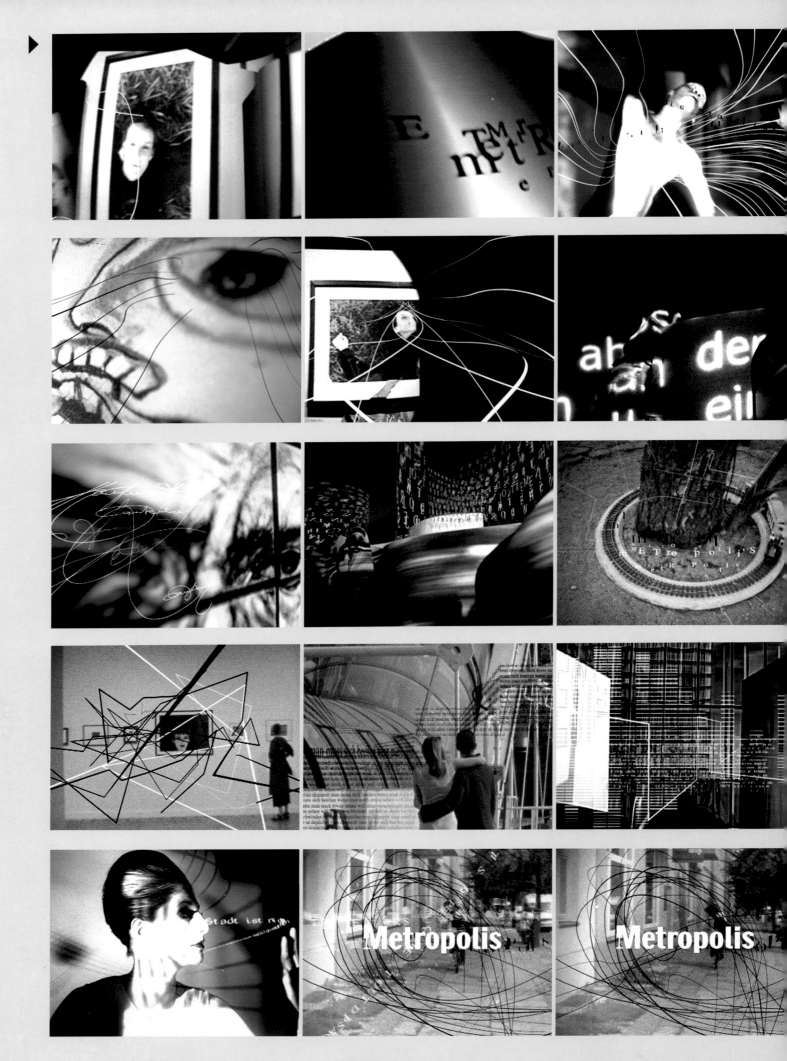

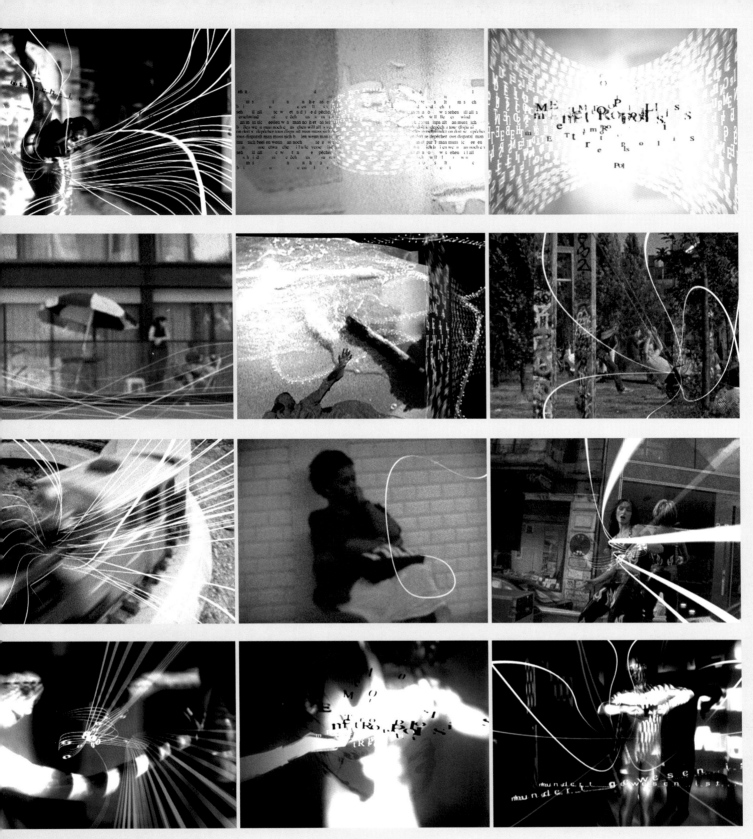

Project Title: Metropolis
Project Type: Project Open
Channel/Venue: arte (French/German Culture Channel)
Creative Director: Matthias Zentner
Design & Animation: Peter Pedall, Hartwig Tesar
Producer: Georgia Caramichu
Director of Photography: Torsten Lippstock
Gaffer: Wolfgang Dell
Art Direction, Set: Frank Neumann, Alexander Lana
Styling: Katharina Ost
Make-up: Michelle Timana
Editor: Jochen Kraus
Compositing: Matthias Zentner, Andrea Bednarz
Music: Novaprod
Software: Avid, Adobe AfterEffects, Cinema 4D,
Quantel Editbox
Hardware: G4 Macintosh, Quantel

student income by working as a photographer and writer. After I began working as an editor, I realized I had to make the decision whether to continue studying or plunge headfirst into the undeveloped field of broadcast graphics. I decided for the latter adventure.

MG: Are you from Munich originally?

MZ: I grew up very close to Munich but was always inspired by other cultural influences. I discovered other countries early on and was always curious about the world. For this reason, I don't really consider myself to have many "local attributes". There is no special need for Velvet to stay in Munich and we have often discussed moving to another city.

MG: What is your preferred method of working?

MZ: I don't give much thought to software or hardware. Those things are just tools to serve ideas. My preferred method of working involves having control of the overall project from the first brainstorm to the final frame tweaking. I love shooting and editing and I enjoy enclosing myself in the Avid suite to cut the final piece. As we began taking on bigger and bigger projects, I had to learn to share some of the responsibility. To do this, we now bring together special teams for each project.

MG: Our industry has undergone profound change in the past ten years. In what ways has your process changed since you first began?

MZ: Post-production facilities aren't the powerhouses they once were. In earlier days, machines dominated every aspect of this work, now it's the artists who are valued. But, sadly, a lot of cut and paste processes are diluting our design language. There is less individual work on the air now than even five years ago. I believe people had more courage in the earlier days. There is too much emphasis on what the competition is rather than on innovation. There is no future in that.

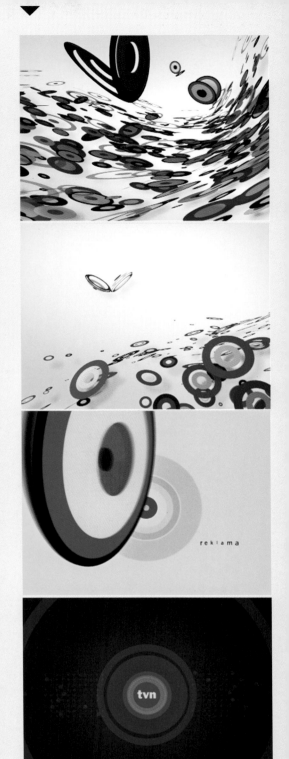

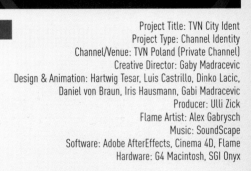

Project Title: TVN City Ident
Project Type: Channel Identity
Channel/Venue: TVN Poland (Private Channel)
Creative Director: Gaby Madracevic
Design & Animation: Hartwig Tesar, Luis Castrillo, Dinko Lacic,
Daniel von Braun, Iris Hausmann, Gabi Madracevic
Producer: Ulli Zick
Flame Artist: Alex Gabrysch
Music: SoundScape
Software: Adobe AfterEffects, Cinema 4D, Flame
Hardware: G4 Macintosh, SGI Onyx

Project Title: Voxtours
Project Type: Program Open & Related Elements
Channel/Venue: VOX Germany
Creative Director: Matthias Zentner
Art Director: Gaby Madracevic
Design & Animation: Matthias Zentner, Gaby Madracevic, Romy
Voigtländer, Iris Hausmann
Camera: Sebastian Milaszewski
Editing: Matthias Zentner, Jochen Kraus
Styling: Christel Wein
Flame Artist: Alex Gabrysch
3D Animation: Andreas Illenseer, Black Mountain
Sound Design: Christoph Blaser, Black Mountain
Software: Adobe AfterEffects, Maya, Studio 3D Max, Combustion, Flame
Hardware: G4 Macintosh, NT, SGI Onyx

Shannon Davis / Turner Classic Movies / North America & Europe

I've often wondered if the designer makes the job or if the job makes the designer. In the case of Shannon Davis and Turner Classic Movies (TCM), the two are completely intertwined. Hers is a career made from pure creativity and hard work. She tells stories about stories and in the process has created a virtual world of dreams.

Melanie Goux: Tell me about the Painting with Light series. How was the project initiated?

Shannon Davis: The Painting with Light series began when I realized there were many film stars who also liked to paint. A book had recently been published on the subject and my boss and I were flipping through it together when he suggested we might do something with the idea. At first, all I knew was I didn't want them to actually paint. I also knew the idea would need to tie into film.

Not long afterwards, I ran across an article about physics and light that included a frozen image of someone drawing with a flashlight. Film requires light to record and view the image. It also has the facility to capture light in motion at slow shutter speeds. Gradually, the idea of painting with light on film emerged, along with the notion of a tribute.

I liked this idea because it involved spontaneity, art and something you don't often see: images of stars are always so pristine, so beautiful, and I was interested in the idea of making them more sketchlike, more of a doodle.

MG: Did the shoot require much direction from you or did you simply let Vincent Gallo go and hope it would all turn out well in the end?

SD: When he came to the set, everything was set up. I had already figured out how to make the idea work technically, so rather than direction, I gave him this arena or blank canvas, and then asked him to draw in midair. The vulnerability of the participant in

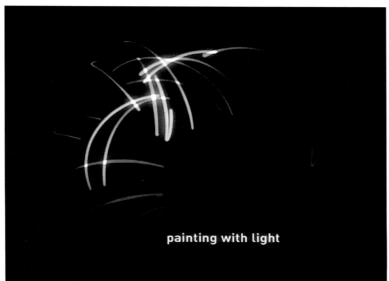

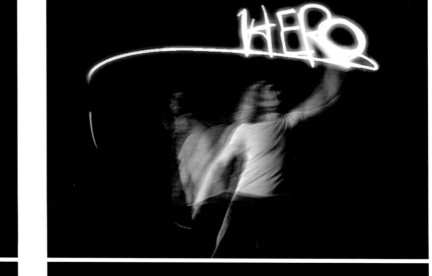

painting with light

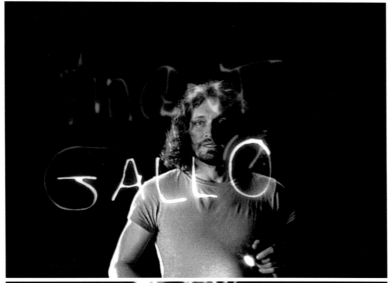

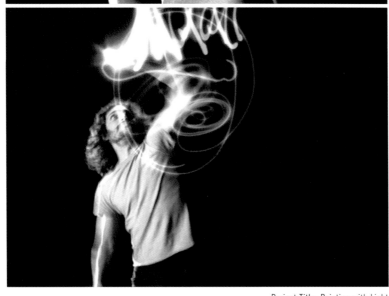

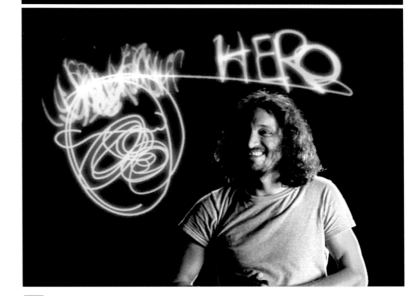

Project Title: Painting with Light
Project Type: Image Promo
Channel/Venue: Turner Classic Movies USA/Europe
Creative Director: Shannon Davis
Flame Artist: Pete McGlasham
Featured Artist: Vincent Gallo
Software: Flame
Hardware: SGI Octane

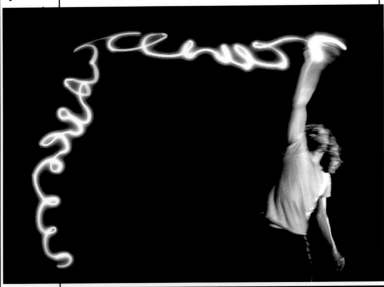

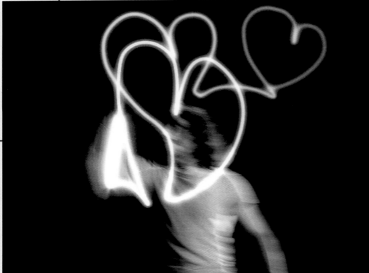

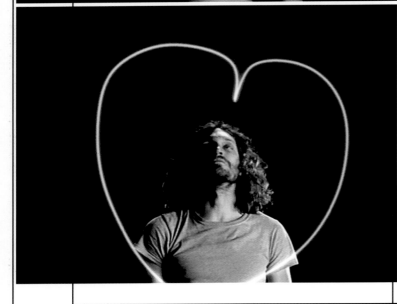

the process was the most fun. I could see what he was drawing, but he couldn't. Several times he asked, "Tell me, am I doing this right?" And I said, "Yes, yes, it's going to look great!"

The first piece was to be his impression of Warren Beatty from the film All Fall Down. The second piece came from my saying, "Now, just do your impression of the love scene from the film." He created what he called "Love Nest", which I loved just as much.

Afterwards, we took his drawings (he drew for half an hour) along with his voice, music, and scenes from the film, then edited, manipulated and mixed them into two finished pieces. That's what I found most interesting about the project. He made something unfinished. Something that needed to be edited, cut together, and assembled to become complete. And that's what I did.

MG: Do you prefer found music or post-scored, original music for your projects?

SD: For Painting with Light, I knew I wanted a different piece of music for every person who drew. Vincent Gallo is the first in a series of artists [others are: Ricky Lee Jones, Alan Cumming, James Fox, Dennis Leary, Alan Rickman, Sissy Spacek, Ving Rhaims, and Deborah Harry]. As it happened, Vincent had just come out with an album and I was listening to it before going into the edit suite. There was one cut, in particular, that I liked very much. We were fortunate to be able to use that cut as the track for his pieces.

The music for the City Lights piece was a composition by Samuel Barber from his piano nocturnes. I was listening to the CD one day, while looking through a book of black-and-white photography of New York City. As I heard the music, it sounded like the lights going on in the city. The piano keys were so clean and clear, I could see a story line developing visually with the music.

MG: This was happening as you were seeing the photographs?

SD: Yes, there was one photograph in particular of the skyline. It was very, very dark and only the little windows were visible. Going into the project, I knew the idea of lights in a city wasn't new, but I wanted to create the feeling of flying through a city and have the lights prompted by, or be orchestrated to, the music.

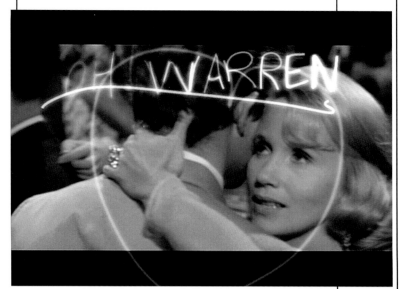

The only time I had seen something similar was in city aerials shot from a helicopter. But instead of live action, I wanted to interpret the idea in a more graphic, abstract way. The Flame artist kept asking, "Should we put more real things in here?" But I thought not. I wanted the piece to simply be about the abstract shapes and the music.

The squares and rectangles of the city, forming and subtracting, are the reason the piece works for the channel. The identity of the channel is based on two ideas: the notion of what I call the "celluloid city," and the idea of film as art. With few exceptions, everything we do is based on art and architecture. These are the areas we draw from when coming up with ideas.

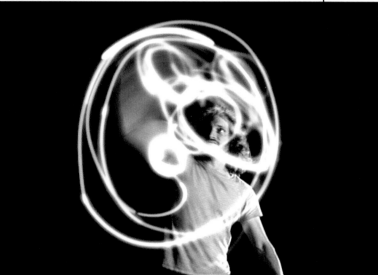

MG: You see the channel as a tangible place?

SD: Very much so and we talk about it as such.

MG: Does everyone you work with have this same "sense of place?"

SD: When I first moved to Europe, I was working with very young producers and designers, and it took a while before they understood the philosophy. During one of our first meetings, I asked everyone to come back in a week and bring three things they thought represented TCM. The only rules were: no movie posters, no star photos or anything that related directly to film.

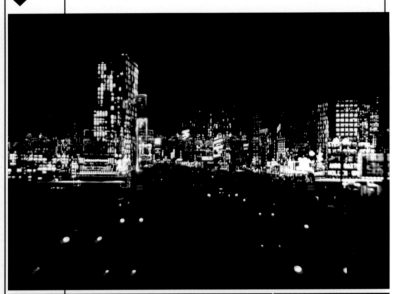

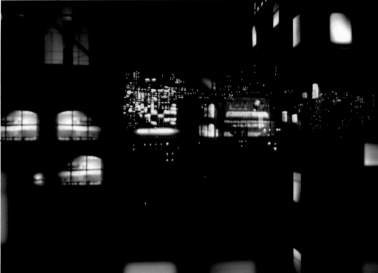

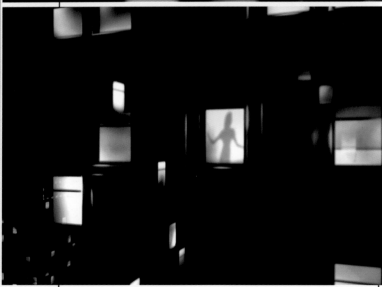

Someone brought book jackets, some brought art, some brought three words, one person brought an ashtray, pack of cigarettes and a matchbook. Collectively, we were able to group these things together, almost as a map of words and objects. Those things are what created, or helped to define the channel, by making it more about real life.

MG: Is this collection of objects added to?

SD: Constantly. It's become something like a mural. We've photographed it several times as it's grown.

MG: What's the practical side of this interpretive approach?

SD: In terms of scriptwriting for example, it's a constant struggle to keep from falling back on traditional ideas and approaches. In my opinion, very few people keep a piece of paper and a pen by their side to write down the time a show will be on. Although communicating practical information is part of our job, I believe it's also important to create an atmosphere in which people will want to spend time. That's why we always try to strike a balance between the more interpretive and informational pieces on the channel.

MG: This explains the emotional quality I've always found in your work. Does every project tell a story?

SD: Definitely. This stems from the fact that TCM is a movie channel and movies are about telling stories. Good stories create some kind of emotion. To my mind, that's what branding is. So even though my job is to sell this channel, I am selling it in the purest way I know how, by telling stories. The City Lights piece for example was produced not long after I moved to London from Atlanta. I missed those really big skyscrapers and skylines of large US cities. So, I think that emotion comes through in the images and music of the piece as something anyone can share, which is like the feeling of missing home.

MG: This is a technical medium. How much consideration do you give to technical and budgetary constraints when coming up with ideas?

SD: I never consider how I'm going to do something until I first figure out what I want to do. I'm truly insistent on separating creative and practical issues during the early stages of an idea. City Lights is a perfect example. I believed in the idea and knew it would be important for the channel, but couldn't afford to produce it all at once. Instead, I had to stretch the production across four months and save money on other projects to cover expenses.

Fortunately, there was no fixed deadline on the project, which allowed me the extra time. Otherwise, the piece would never have been produced. For projects with fixed deadlines, we sometimes have to make concessions. That said, there are certain pieces, such as image pieces and openers, where I never compromise. I believe those pieces are the cornerstones of the channel and, if done well, will last for many years.

Project Title: City Lights
Project Type: Image Promo
Channel/Venue: Turner Classic Movies USA/Europe
Creative Director: Shannon Davis
Flame Artist: Pete McGlasham
Software: Flame
Hardware: SGI Octane

David Carson / David Carson Design / New York, New York USA

David Carson's motion graphic design work has a very different look and feel from most. This is due, in part, to the fact that he came to motion graphics as a seasoned print designer, but also because he seems remarkably undaunted by changes in medium. Although he directs, rather than animates, this has not diminished his creative effectiveness. Indeed, his unmistakable sensibility comes across clearly and to excellent effect in his motion graphic design work, proving that technical skill is no substitute for fluent design.

Melanie Goux: In "2nd Sight", you quote Paul Rand as having said, "There is no difference between an artist and a designer, both work with form and content." I found this interesting, since most of your work is more like fine art than graphic design. If I didn't know, I would guess you were trained as a painter.

David Carson: I have no training in either, but have always been drawn to fine art. I often think I'm just painting with type and images. Some of my layouts are heavily influenced by Mark Rothko paintings. I enjoy painting and would like to take a painting course some day.

MG: You had a long-established reputation as a print designer before ever beginning to work in

No great discovery

ever happened wit

change

is the path of
most
Resistance

No great discovery

ever happened

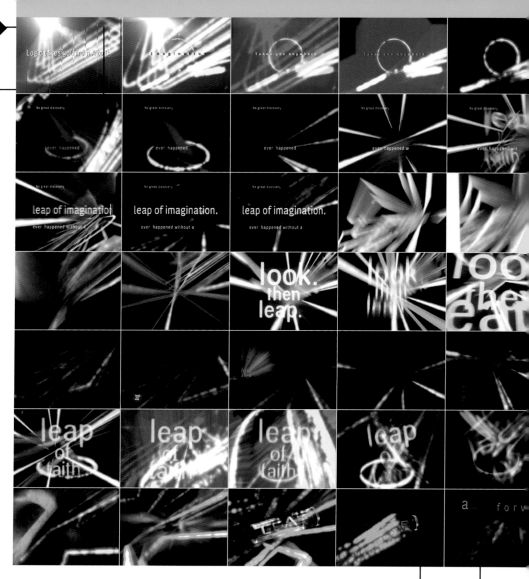

motion. What was your first motion graphic design project?

DC: The director Tony Kaye called and asked if I could put some type on a music video he was working on. It was fascinating to see the type actually move for the first time. So about the time many designers were heading for the web, I ran to motion graphics, film titles, and broadcast design.

MG: Do you envision working more with motion and less with print in the future, or will print always be your preferred medium?
DC: I'll always work with some form of print, but I'm much more interested in anything moving nowadays.

MG: Is your creative process different when designing for motion?

DC: No. The emotional content of the message

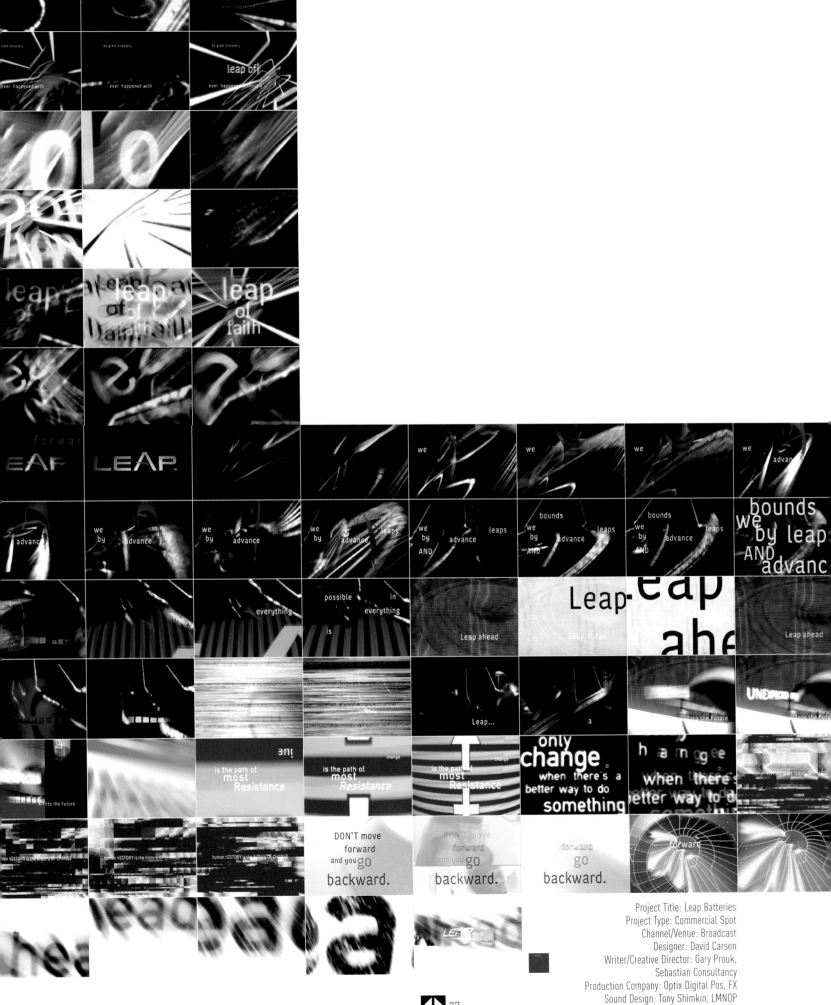

Project Title: Leap Batteries
Project Type: Commercial Spot
Channel/Venue: Broadcast
Designer: David Carson
Writer/Creative Director: Gary Prouk,
Sebastian Consultancy
Production Company: Optix Digital Pos, FX
Sound Design: Tony Shimkin, LMNOP

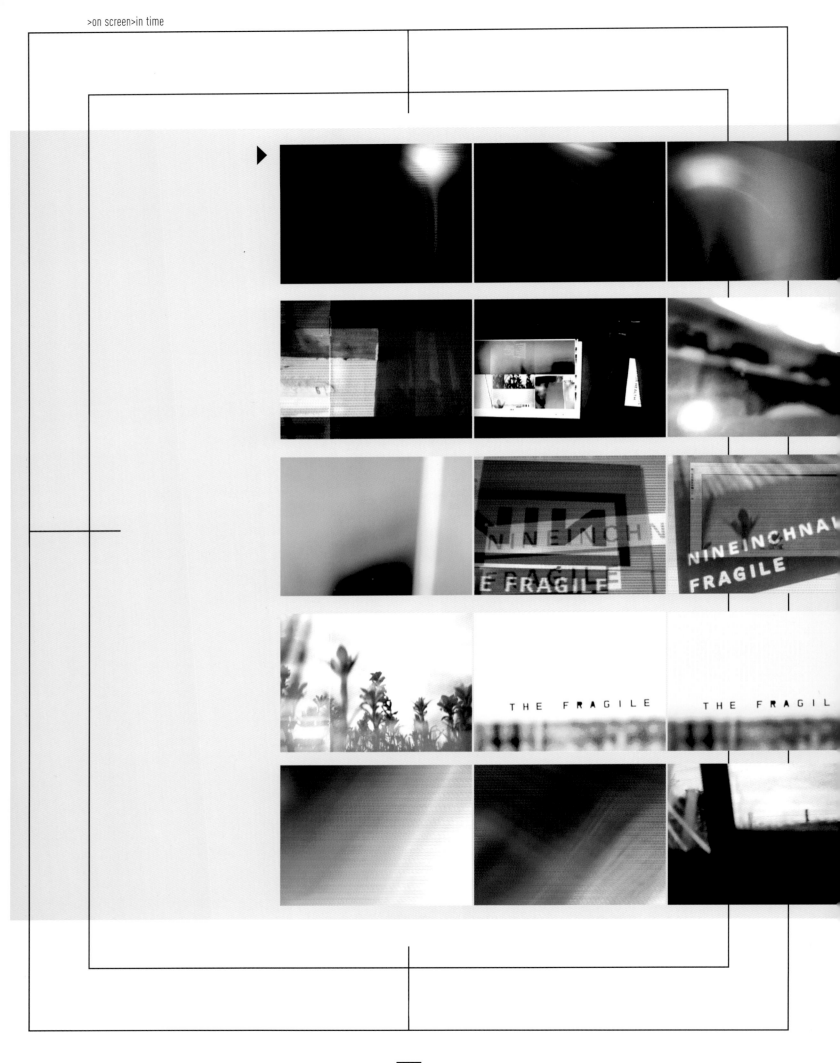

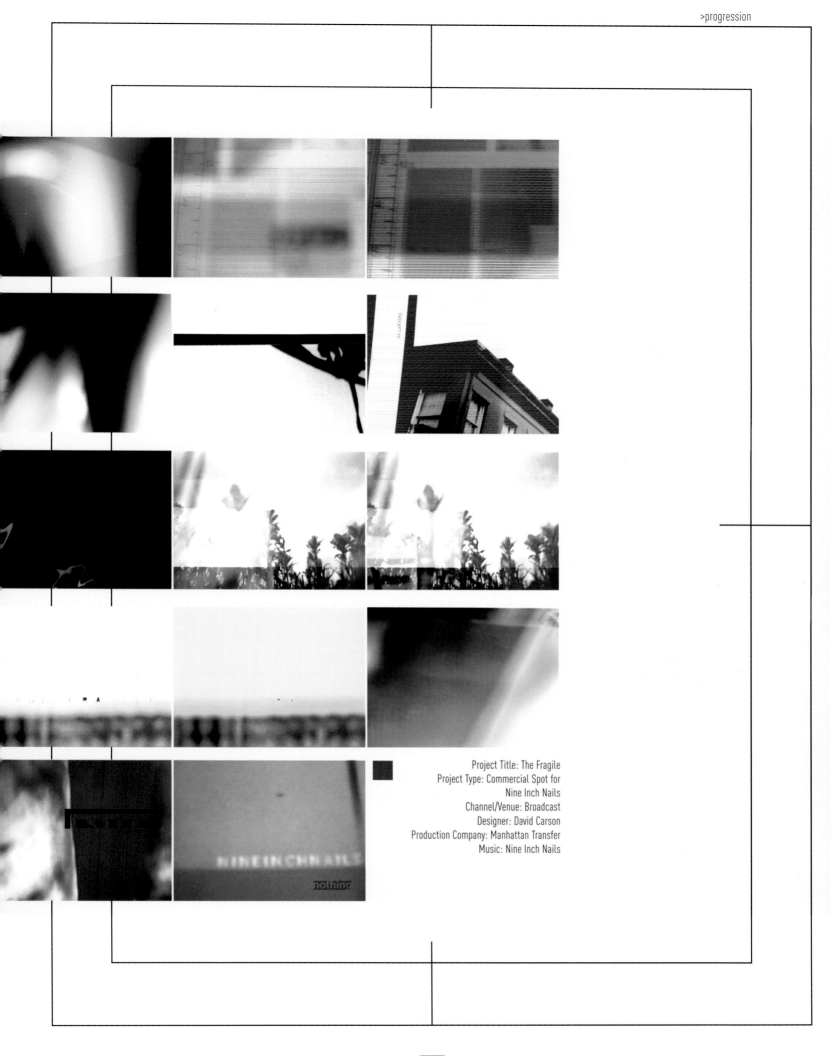

Project Title: The Fragile
Project Type: Commercial Spot for
Nine Inch Nails
Channel/Venue: Broadcast
Designer: David Carson
Production Company: Manhattan Transfer
Music: Nine Inch Nails

DC: No. The emotional content of the message I want to convey through design is always realized by the same approach: intuitive, subjective, personal, and self-indulgent.

MG: The spots you designed for Leap Batteries could be described as corporate poetry. Were you involved in the content, or were you approached because of your known fluency with type?

DC: I was very involved with the whole process and find that's often where the best work comes from. And, yes, I'd say corporate poetry is a pretty accurate description of that piece.

MG: The wordplay is hypnotic. Have you, or will you ever produce a pure design project in this way? For example, would you ever produce your [print publication] "Book of Probes" in motion?

DC: The Leap project had a great deal of freedom, as do most projects I choose to work on, but yes "Probes" in motion would be great.

MG: I've heard you always carry a small still camera with you. In the years since you've been producing motion graphics, have you also begun to carry a small video camera?

DC: No, but that's not a bad idea.

MG: You're known as a non-technician, yet producing high-end motion graphics often requires great technical skill. Are there people you rely upon, or routinely collaborate with, for motion projects?

DC: I work with a variety of post houses, but always in a situation where I'm directing their operators, since, yes, I am rather low-tech. I find keeping a certain distance from the technical minutiae helps my design process.

MG: What one thing would you change about the industry's professional practices?

DC: When clients hire someone because they like what they do, they should let them get on and do it.

MG: You're a prolific designer of print, motion graphics, web sites, exhibits, and books and you also teach. What aspects of your creative life do you most enjoy?

DC: All of them, but I'm still content simply to sit in front of my screen (music going, coffee on), just experimenting, playing, and/or working. Eventually, if I don't end up painting or directing documentaries, I may turn to teaching.

MG: Are you more interested in the future or the past?

DC: You've got to stay interested in the future, and especially the now. Besides, I've never been much of a history buff.

41

The Designer's Republic / Sheffield, UK

The responses in the following interview may seem sparse and robotic, but there is something appealing in The Designer's Republic's consistent ability to leave us wanting. We may never really know the personalities behind the Republic, but in my few brief encounters, I found them to be responsive and personable. They are one of the few firms who (contrived or not), have somehow realized the design student's dream of garnering notoriety and respect more through their work than their words. The result is a potent blend of fame and anonymity that continues to hold our interest. And yes, there is also the work. But however well conceived or prescient it may be, it is not all there is. In the case of TDR, to quote media culture author Leslie Harpold, "Hypermodernism has a posse" (http://www.leslie.harpold.com).

Melanie Goux: A couple of years ago, The Designer's Republic (TDR) created a video for the band Funkstörung that became a breakthrough piece. Even now, it is much discussed, imitated and admired, especially by younger motion graphic designers. Was this video the first piece of motion graphic design that TDR had ever produced?

The Designer's Republic: Yes.

MG: This piece is technically simple, but very well done. The editing, in particular, is extremely tight. Were you inspired more by the music or simply the idea of working with motion?

Project Title: Grammy Winners/229 Seconds
Project Type: Music Video for Funkstörung
Channel/Venue: Broadcast
Creative Director: The Designer's Republic
Designer: The Designer's Republic
Software: Brains
Hardware: Computers

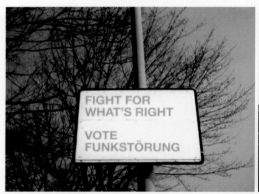

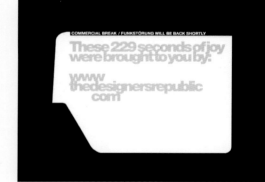
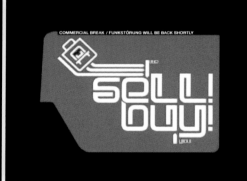

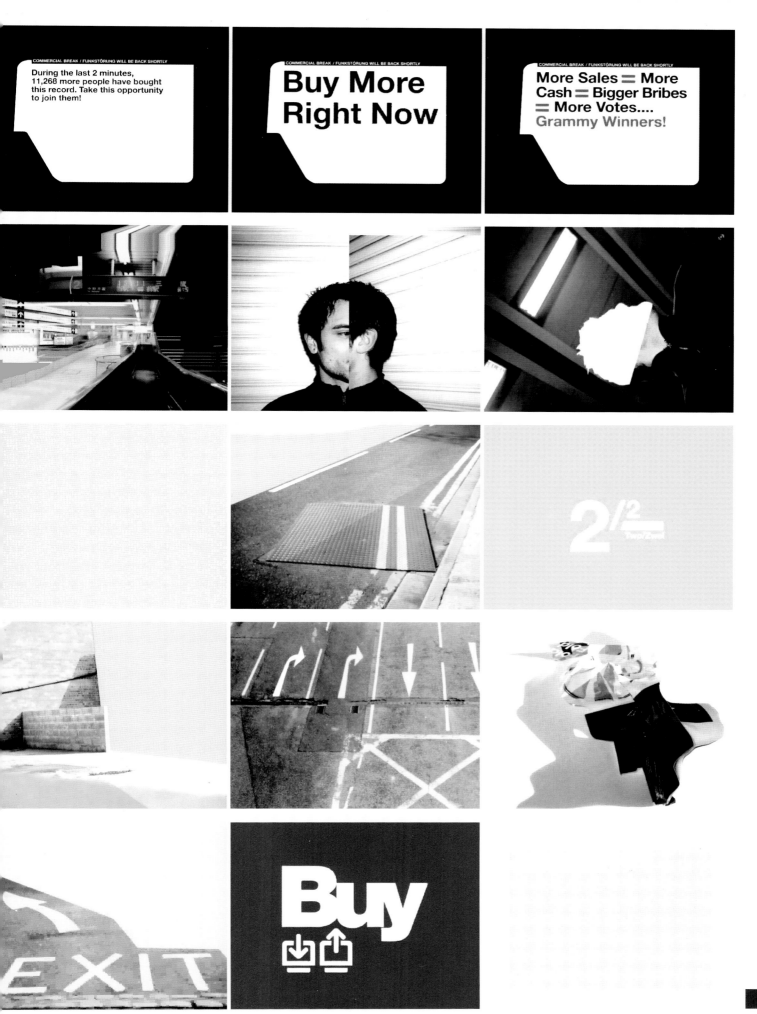

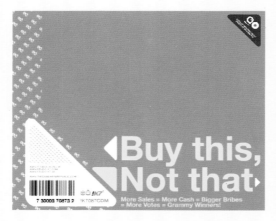

Project Title: Grammy Winners/229 Seconds
Project Type: Packaging for Funkstörung CD
Channel/Venue: Retail
Designer: The Designer's Republic

TDR: It isn't motion, it's sequential graphics inspired by the idea of the music. The simplicity of its production isn't an issue.

MG: How does your design process differ for motion graphics rather than for print or web design?

TDR: It doesn't.

MG: Motion graphic design can be somewhat addictive. Once it gets into the bloodstream, it's difficult to imagine doing anything else. Have you been bitten?

TDR: Being creative is addictive. Thinking is addictive. Working in the same medium all the time is dull.

MG: What is the best part of a project?

TDR: The process.

MG: Did you have a sense as you were creating 229 Seconds, that it would generate such an overwhelming response?

TDR: It was never an issue.

MG: I'm fond of the piece, but wouldn't have predicted it would spawn so many imitations. At which point does imitation become detrimental to TDR?

TDR: At the moment someone denies their own opportunity to create something individual by hitting the TDR-filter button.

MG: How was the video produced? Was it done using Adobe AfterEffects?

TDR: Two balls of string and an egg.

MG: The Designer's Republic was founded in 1986. So, I'm guessing your fan base is a bit younger than the group. That's not to say the firm isn't admired, but young designers in particular seem especially fanatical about TDR. How does it feel to be the perpetual ingenue?

TDR: It's an honor and a privilege.

MG: Do you find this cult following annoying?

TDR: Flattering.

MG: Having been so popular for so long, do you feel more pressure with each new project?

TDR: We don't design to be popular. Ask our clients.

MG: Having started the company slightly before the era of desktop publishing, you have both "old school" and "new school" skills. Do you consider motion graphic design as a new phase for TDR or simply as another addition to the group's skill set?

TDR: It's just a different means of expressing ideas.

MG: In the arc of a company, where is TDR now?

TDR: At the beginning.

MG: Has the core group at TDR remained consistent or has it varied through the years?

TDR: Consistent and varied.

MG: Your work is always credited to TDR, never to individual designers within the group. Was it a conscious decision, made early on, not to single out individuals in favor of the group?

TDR: A conscious decision from day one.

MG: Do you ever envision a time when TDR will no longer design print work or will produce significantly less print in favor of electronic media?

TDR: No plans.

MG: What is the most common misconception about TDR?

TDR: All the above.

2.

>shift

Elaine Cantwell / Spark / Hollywood, California USA

Adriana de la Puente / TV Azteca / Mexico City, Mexico

Jeremy Hollister / R!OT / New York, New York USA

Daljit Singh, Merlin Nation / Digit / London, UK

Elaine Cantwell / Spark / Hollywood, California USA

Elaine's work has a refined graphic sensibility which is professionally and appropriately applied to the discipline of visual branding for the screen. The clarity of the message, though presented with style and intrigue, jumps off the screen and tells a beautiful and compelling story. Both the viewer and the client are equally considered.

James Houff: You are originally from Ireland. When did you come to the United States, and what stage were you at with your design and career?

Elaine Cantwell: Before leaving Ireland, I had spent four years working as designer and art director at Arks Advertising Agency in Dublin. During those four years I worked on the Guinness and Levi's accounts predominantly. While on the Guinness account I created a series of spots that involved some very ambitious compositing—which had never been achieved in Ireland before—and because Guinness insisted on all commercials being produced in Ireland, the very first Harriet was purchased by a post-production facility in Dublin. This gave me my first taste of what digital compositing could achieve and it grew from there.

When I arrived in Los Angeles and interviewed at Pittard Sullivan, even though my background was in advertising, my style fitted in with broadcast thinking so I got the job as senior designer. I spent a year getting my feet wet in the world of broadcast design and found it not unlike advertising —you were still selling a product. The challenge was that television is an intangible product, but I still jumped in and immersed myself. I was hired a year later by 3 Ring Circus as creative director.

JH: Do any Irish cultural influences show up in your design in any significant way?

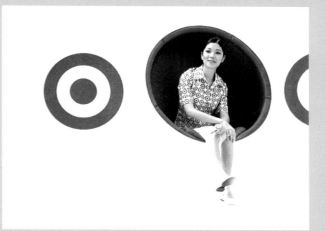
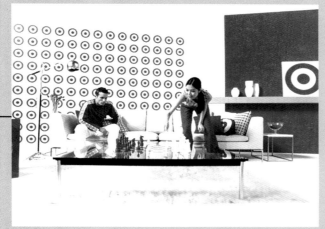
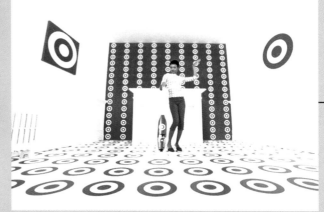

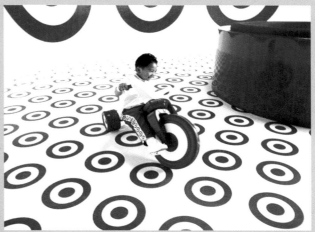

Project Title: Target
Project Type: Commercial Spot
Channel/Venue: Broadcast
Creative Director/Designer: Elaine Cantwell
Director: Elaine Cantwell
Producer: Patty Kiley
Editor: Fischer Edit

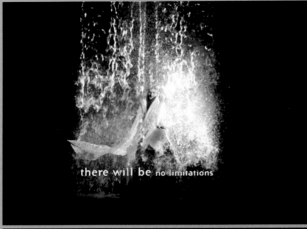

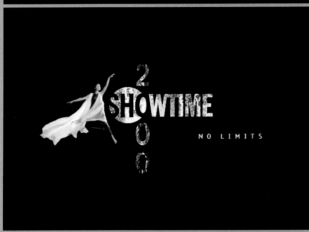

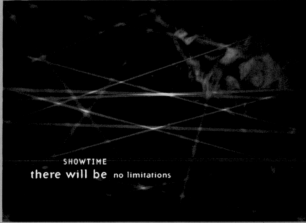

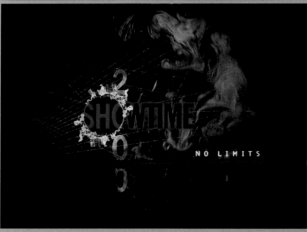

Project Title: Showtime
Project Type: Channel Identity
Channel/Venue: Broadcast
Creative Director/Designer: Elaine Cantwell
Director: Elaine Cantwell
Producer: Patty Kiley
Editor: Jay Lizarraga
Post-Production: View Studio
Music: Manmade Music

EC: I think my Irish upbringing definitely influences the solutions I arrive at. In many ways, much of the American television culture is still new to me— I have never seen an episode of Gilligan's Island!— but I think it is because of that, that I tackle the creative problem in a slightly different, if sometimes offbeat manner. I also feel that the Irish education system is very vigorous and really prepares you for the world of work. I had a couple of great tutors in art college who gave me some brilliant advice:
a. If you don't believe in your gut that the solution is right, then don't present it, even if you think that's what the client wants;
b. Don't be afraid to get it wrong because we always get it wrong, otherwise we'd never do anything over and we would never learn from our experiences;
c. Don't tell anyone how young you really are!

JH: Your work for the retailer Target has been very visible. The spots are very graphic in their aesthetic, very designed. As a designer, where do you enter the process? Can you talk about how these spots came together?

EC: The (advertising agency responsible for commissioning us) really wanted to collaborate on the commercial interpretation of the Target brand. They had begun to explore the idea of the logo as an icon or beacon of style in terms of print, and wanted to see what ideas I had regarding the commercial spot. At this point I began to develop some written treatments and styleframes to illustrate how the spot could evolve. The Sign of the Times track by Petula Clark really set the tone for the spot, giving it a retro-modern flavor. It was really a great collaborative process with the agency batting ideas back and forth, pushing the idea as far as it could go. The stylistic attitude of the spots is very much a favored look of mine, with many mid-century Modern influences leading the aesthetic. After the first launch spot, I evolved the campaign for the holiday season, expanding the Target language to accommodate the gift-giving and entertaining messages of the season.

JH: Has there been any consensus on whether these spots moved the market in any noticeable way? Did brand recognition or sales increase as a result of them?

EC: The spots definitely separated Target from the fray of discount retail stores, defining it as the hip place to get your basics as well as some really cool elements from designers such as Philippe Starck and Michael Graves. The key to Target's success was that it did not alienate its core audience by changing its product range entirely. It simply pushed a lifestyle message to the forefront and supported it through some key merchandising.

Target is a successful example of how image marketing can work: you don't always have to push a value message to increase sales. Just make your store a place where people want to go and be seen and you have success.

I also think that Target changed how the discount retailer and discount brands market themselves. You look at Kmart, Old Navy, Wal-Mart—they have all jumped on the bandwagon of image branding, but you must support your statement with the merchandise. The consumer is smart enough to see past a cool, hip façade.

JH: I am curious about your process. Much of your work has a very lavish quality. There is often live action, Computer Generated Imagery (CGI) and the appearance of elaborate compositing and effects. How do you go about conceiving and visualizing this for yourself and your clients before you begin production?

EC: After evaluating and absorbing everything there is to know about the product or brand and its audience, I brainstorm in written form without the restrictions of having to visualize those ideas. So I begin with a written concept. The first step is to figure out what you want to say, what the message is. Once you figure that out and get consensus,

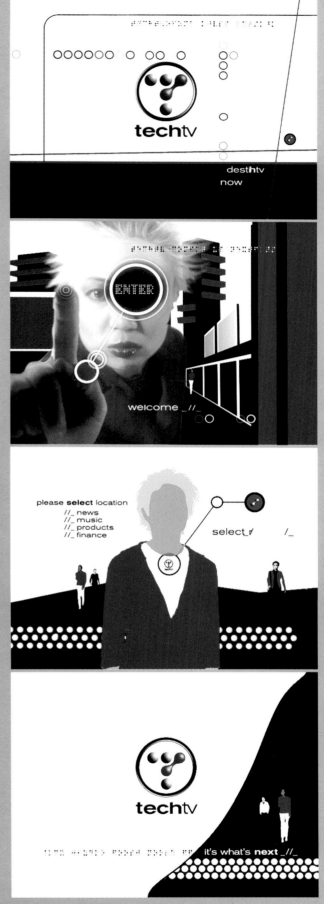

Project Title: Techtv
Project Type: Channel Identity
Channel/Venue: Techtv
Creative Director/Designer: Elaine Cantwell
Director: Elaine Cantwell
Producer: Beth Elder
Editor: Jeremy Quayhackx
Post-Production: Ring of Fire
Music: Manmade Music

Project Title: ZDTV
Project Type: Channel Identity
Channel/Venue: ZDTV
Creative Director/Designer: Elaine Cantwell
Director: Elaine Cantwell
Producer: Johnny Wow
Editor: Jay Lizarraga
Post-Production: Milnefx
Music: Manmade Music

there are a million ways to visualize it. This is where the brand attributes and target demo come into play. Visualizing the same message to an MTV audience will differ greatly to the visual expression of that message to the CNN audience; even though you may be saying the same thing. Once the written concept is agreed upon, then the visual exploration begins. I create styleframes as close to the final end product as possible, indicating photographic look and feel as well as narrative content. This really helps everyone on the team, including the client, to understand the vision and the task required to make that vision happen. So, with a clear set of styleframes in hand and a message to state, the process of making it real begins and sometimes that is really where the challenge lies. I rarely allow the production process to limit the creative process in terms of defining what is in the realm of possibility. Otherwise we would only ever do what we know how to do.

JH: Tell me about your production process. I assume you work with teams of people?

EC: Some might call me a control freak but I am involved in every step of the process from conception to on-air birth. This is where I really learn. I have to figure how to make it happen because I don't just hand it over to an art director to animate. I write my own concepts, visualize my own boards, direct any live action, and supervise all post-production. The only part I don't physically do myself is animate or edit because there are far superior artists out there focusing on different areas of compositing.

JH: It seems impossible to master all the aspects of production in order to create the type of work that clients now expect. How would you advise designers interested in this type of work to arm themselves with broad enough skill bases?

EC: My philosophy is to find the best talent out there to achieve the given solution—if it requires

traditional cell animation then my job is to find the person out there who is the best at that one thing and apply their talents to the project. My role in post-production is to make the decisions and keep every part of the process on track.

Having an overall knowledge of what's possible is definitely a requirement to be able to communicate ideas that push the envelope. I don't feel it necessary to be an expert in each of the different platforms but it really helps if you understand the process and system of whatever platform you are using. You are really part of a team and when trying to achieve things that have never been done before, two heads are always better than one. It helps to have one person coming at it from a conceptual perspective and the other from a more technical perspective and between the two of you, you know how to arrive at something really visionary and innovative. I think, as a designer, if you are decisive and know what you are trying to achieve, then people will get on board, whether client or production. It's all about having something to say and saying it clearly.

Project Title: W Network
Project Type: Channel Identity
Channel/Venue: W Network
Creative Director/Designer: Elaine Cantwell
Producer: Patty Kiley
Post-Production: Ring of Fire
Music: Manmade Music

Adriana de la Puente / TV Azteca / Mexico City, Mexico

In a world of increasing globalization and mass communication, there are still cultural secrets known only to those steeped in the ethos or history of a place. Adriana de la Puente knows the secrets of Mexico and shares them with her viewers as if they were friends. Although her creativity isn't limited by region, her images for TV Azteca are perfectly informed, realized, and well communicated. She is a designer in her own element.

Melanie Goux: How did you first become interested in broadcast design? And how did you get started in the field?

Adriana de la Puente: I actually grew up working for a television station in Mexico. My aunt was a television presenter in a show and I used to appear on screen with her. After that, I decided to study communication, and later earned a master's degree in philosophy. My parents are both architects and my brothers and sister are designers, so I was always surrounded by art and design. Now I work as creative director at TV Azteca.

MG: The Images of Mexico campaign for TV Azteca makes use of a simple, but effective idea. Each piece begins with a painting that, at first glance, appears flat. The camera zooms in and changes orientation slightly, until we realize the scene also includes a person, painted like a chameleon, to blend perfectly with the art. The effect is pleasantly surprising. Tell me about the origination of the idea. Did the execution involve a lengthy production process? The make-up work alone must have taken many hours.

AdlP: I believe neither design nor art are effective unless they are expressive. In Images of Mexico we had many things we wanted to communicate. First, we wanted people to recognize TV Azteca as a human channel. Also, we wanted to express the network values and the identification with our roots. We knew early on that we didn't want the images to

be generated electronically, mainly because we wanted the images to have a warm, organic and human feel. Generally, we believe electronic images are emotionally distant.

We worked on the overall concept, as well as the specific design ideas in parallel. After the concept was complete in our minds, we had a lengthy production meeting prior to filming, to sort out the details. The biggest challenge of the project was to make the most of the idea. So we began by making a few test shots of models, to find the best camera angles and moves. Indeed, it was a time-consuming process. We spent around four to five hours painting each model and approximately six to eight hours painting each of the matching backdrops. We shot each of the twelve models for about two hours.

MG: You mentioned the network "values." The main feature of TV Azteca's identity is the visual representation of values such as: generosity, family, passion, vision, and honesty, to name a few. The Images of Mexico project illustrates each of these, but it was not the first expression of the concept. Tell us about the thinking behind the values and how they came to be used as a branding tool for the channel.

AdlP: The original challenge for us was to define what is Mexican. We are a culture with prehistoric roots, but also have Spanish and French influences. Taken together, this is what we call "the Mestizo culture." Although modern Mexicans are citizens of the world, we have our own unique culture that is much more than folk art and pyramids. So, how to express this complexity, how to express what is really Mexican, was the inspiration behind selecting the best values of our culture as icons for the TV Azteca identity.

To help express these values, most of which are abstract concepts, we chose the images of Mexico: flowers, fruits, animals, and those things we see every day of our lives. The monarch butterfly, for

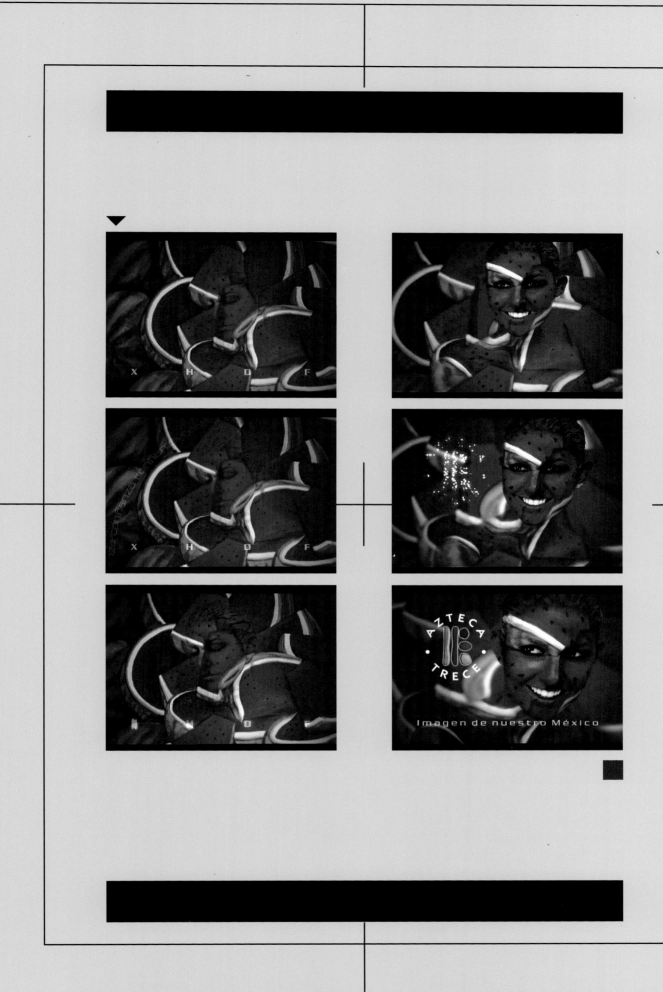

example, isn't necessarily Mexican. Strictly speaking, it is Canadian, but every year the butterflies come to Mexico to take refuge from the cold, so we have adopted them as our own.

MG: Both projects featured in these pages were shot on film. Do you always rely on film for image acquisition? Do you believe the image quality of High Definition Video (HDV) will eventually exceed that of film?

AdlP: Whenever possible, I prefer to shoot 35mm film. I believe the image quality of film is still better, softer, and warmer than that of video. Although it is very expensive, when it comes to acquiring images for our network, we believe in using the best techniques. We haven't yet shot in HDV, but I am sure it will change the industry because it will lift the standards for all television production. Still, I don't envision HDV will ever completely replace film for high-end, large-budget production.

MG: How do you balance the twin forces of design and technology? Do you ever feel overwhelmed by all the technology available to you?

AdlP: The distribution of our forces is very interesting. We have two teams: designers and creatives, and together we manage to work through most issues. All the tools in the world are only useful if you have something to say, so we never allow technology to drive our creative process. When the creative team has a strong concept, the design team then employs the best technology to express that concept. If they aren't sure or don't know how to execute an idea, they start investigating options. There are few problems they haven't been able to solve.

MG: Let's talk a bit about the World Cup opening titles. I've rarely encountered such beautiful and tasteful packaging for sports programing. Tell me about the idea underlying the images.

AdlP: The idea was to show the domination of the fire that is the World Cup. The ball of fire represents the passion surrounding the competition. It is sort of a Zen master philosophy: he who dominates the ball of fire will dominate the fire of the games. In our interpretation, the characters didn't touch the ball with their bodies, but instead controlled it with their minds.

We also chose to join together the two cultures of Japan and Korea. Although the two are similar, they are not identical. We chose to focus on the similarities. They both share a passion for drums and dance. They both have pagodas and believe in dragons as a symbol of good fortune. So we took the fire-breathing dragon as a symbol for our World Cup broadcast. We knew the other channels would probably just have soccer players in different poses, so we decided to make something more abstract and artistic. We shot against a black background to enhance the beauty of the costumes and the drama of the fire.

MG: What advice would you give to young broadcast designers just starting out?

AdlP: Three points come to mind:
a. Work on the concept first, then worry about technique and process;
b. Always work with a team, rather than alone;
c. Never stop learning. The more you learn about life, the more your work will be enriched.

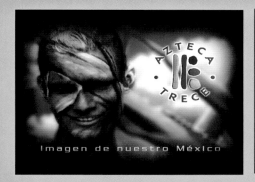 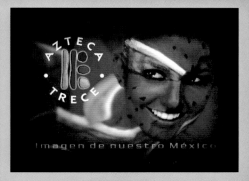

 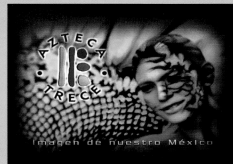 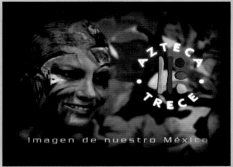

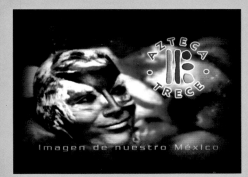 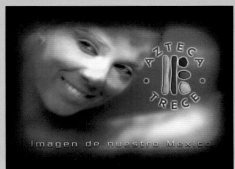 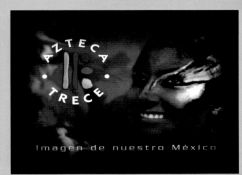

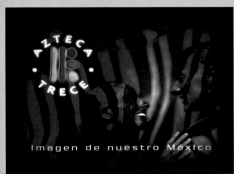

Project Title: Imagen de Nuestro Mexico (Images of Mexico)
Project Type: Channel Identity
Channel/Venue: TV Azteca
Project Producer: Mario San Roman
Project Director: Jaime Pontones Schneider
Creative Director: Adriana de la Puente, Martínez de Castro
Project Art Director: César Bailon González
Director: Juan Carlos Martín
Producer: Leopoldo Soto
Director of Photography: Geronimo Denti
Make-up: Regina Reyes, Fernando Legorreta
Painters: José Luis Aguilar, Julio Gomez

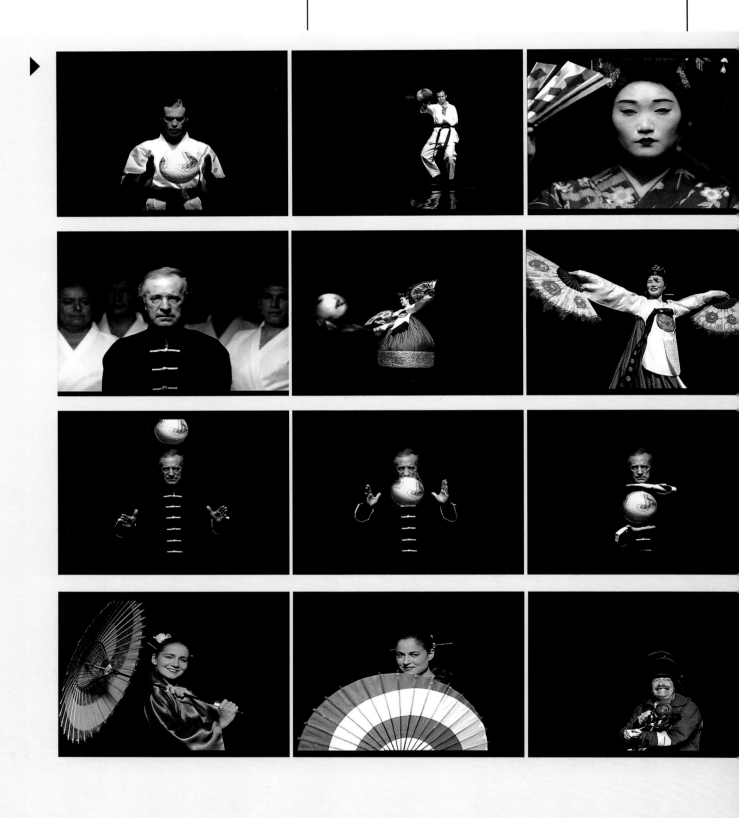

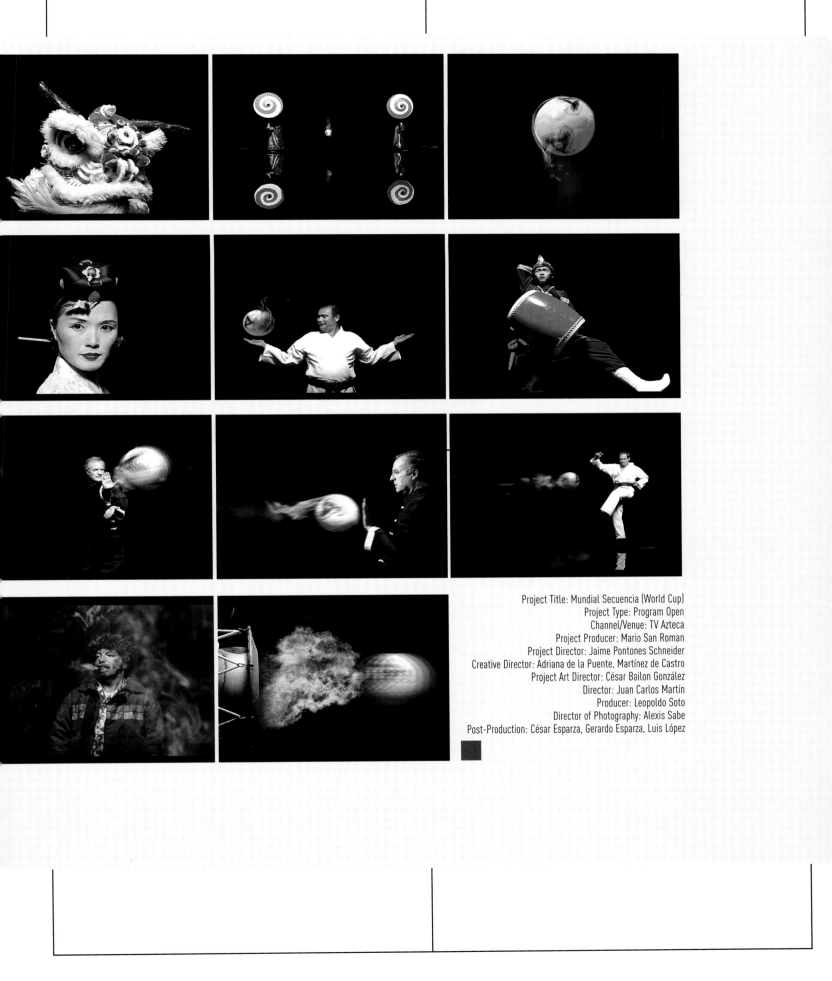

Project Title: Mundial Secuencia (World Cup)
Project Type: Program Open
Channel/Venue: TV Azteca
Project Producer: Mario San Roman
Project Director: Jaime Pontones Schneider
Creative Director: Adriana de la Puente, Martínez de Castro
Project Art Director: César Bailon González
Director: Juan Carlos Martín
Producer: Leopoldo Soto
Director of Photography: Alexis Sabe
Post-Production: César Esparza, Gerardo Esparza, Luis López

Jeremy Hollister / R!OT / New York, New York, USA

At time of writing, Jeremy had just left R!OT to launch his own firm, the name of which is still to be decided. For designers in search of a greater degree of autonomy and creative control, this inevitable step is sometimes difficult to make, but always exciting. New firms, like young designers, are filled with energy and possibilities.

Melanie Goux: Like many talented designers, you've never studied design. Tell us a little of your background.

Jeremy Hollister: My academic background is in Political Science—I came to design later. I was studying post-modern and contemporary political theory and became very interested in media theory —how powerful media was as a means of disseminating ideas and the ramifications of this power—and how the control of media is a phenomenal tool for both the government and corporations. I became interested in subversive groups such as Emergency Broadcast Network and

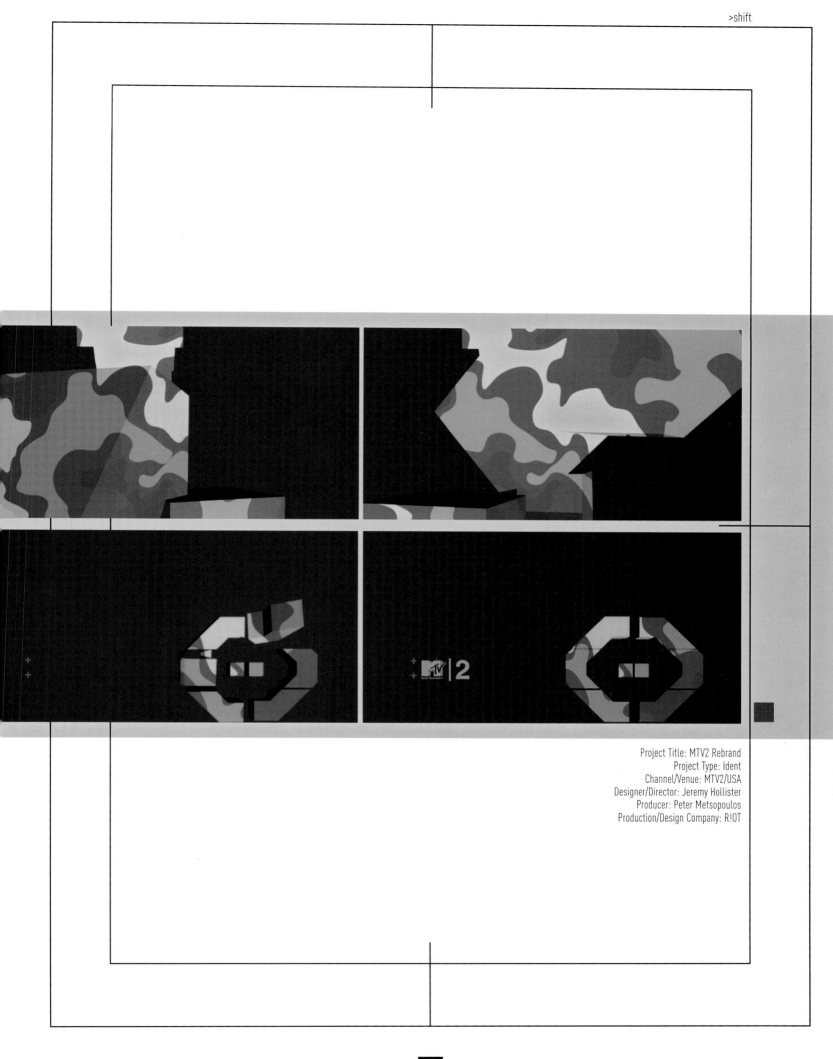

Project Title: MTV2 Rebrand
Project Type: Ident
Channel/Venue: MTV2/USA
Designer/Director: Jeremy Hollister
Producer: Peter Metsopoulos
Production/Design Company: R!OT

the way they recontextualized news footage and commercials. My political science professors were cool enough to let me create visually animated essays rather than writing typical term papers. It was at this point that I began developing my visual aesthetic as a means of catching viewers' attention with my ideas. Later, my postgraduate work was in virtual reality and real-time video performance.

MG: Now that you're here, working professionally in New York as a motion graphic designer, what do you enjoy most and least about this work?

JH: I really enjoy the challenge of working on projects with teams of people, and most animation or film projects require collaboration. Motion is very rewarding to work with as well. I enjoy being able to create a mood over time, and adding music to the process takes the work to another level.

The downside is the time and effort required, as well as the relatively limited availability of outlets for motion work. Television is a bit restrictive as regards who can showcase their work. Air time is extremely expensive, which leads to more conservative attitudes and more layers of opinion.

MG: At thirty-one, you are one of the youngest designers featured here. Are you still in the traditional "experimental stage," or have you begun to notice certain themes recurring in your work?

Project Title: Peacekeeping
Project Type: Editorial Video
Channel/Venue: Installation, NYC,
Re-edited for onedottv/Channel 4, UK
Art Director/Designer: Jeremy Hollister
Music & Composition: Chris Girand

Project Title: Petri
Project Type: Ident
Channel/Venue: SciFi Channel
Designer/Director: Jeremy Hollister
Producer: Peter Metsopoulos
Production/Design Company: R!OT

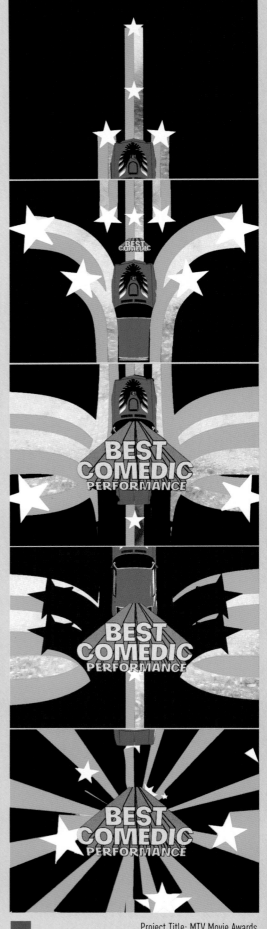

Project Title: MTV Movie Awards
Project Type: Program package
Channel/Venue: MTV/USA
Creative Director/Designer: Jeremy Hollister
Designers: Manwai Chueng, Bill McMullen
Animator/Designer: Mike McKenna
3D Animation: Patricia Heard-Greene, Dylan Maxwell
Producer: Peter Metsopoulos
Executive Producer: Connie Griffin

JH: It's not so much that I am still in an experimental stage, but rather I believe the challenge of any designer is to adapt the approach and technique to suit each project. Principles and ideas are cyclical, but technique becomes dated and stale if it doesn't evolve. I'd like to think it's possible to maintain both the desire and ability to work in this way throughout a lifetime.

MG: This field is relatively new and there are very few motion graphic designers who are over fifty (most of them produced film titles). Do you imagine you will still be working as a motion graphic designer in ten or twenty years, or do you have other plans?

JH: I hope to still be involved with design in some form in the future, but specifics are hard to foresee. I am certain that I'd like to explore working in other mediums such as fashion, installations, and environmental projects. I'd also like to explore narrative on film.

MG: You have already produced an installation, the Peacekeeping animation, which was originally created to run on large projection screens as part of a multimedia display. How did this project come about?

JH: I was invited to show my work at Zakka (a New York City shop and artists' space) and it was my first installation of this type. I saw the project as a good chance to explore political ideas again through graphics and animation. Besides the video, there were six large-scale, silkscreen images on Plexiglass. Later that year (2001), the animation produced for the projections was edited into a three-minute piece that aired on Channel 4 in the UK as part of the onedottv series.

Project Title: Wakeup Screaming
Project Type: Experimental
Channel/Venue: Private Screening
Creative Director/Designer: Jeremy Hollister

Daljit Singh, Merlin Nation / Digit / London, UK

If the future of motion graphic design is convergence, Digit already has a head start. As their name would imply, the group, which has been operating for five years, doesn't hesitate to explore every avenue of digital production. Most admirable is their tendency to subordinate their own egos in favor of the end user. In ways that are both fun and entertaining, Digit design for others as well as themselves.

Melanie Goux: Your company is primarily known for clever design and production of Flash-based web sites, of which the MTV2 site is a fine example. Was the video portion of the MTV2 project your first foray into motion graphic design for television?

Merlin Nation: Yes

MG: The skill set and tools required for the web differ slightly from those of broadcast television. What unexpected challenges did you encounter while producing the MTV2 on-air material?

MN: The production of the on-air work was done by professional 3D broadcast animators. Digit art-directed and oversaw the production. Since we chose not to attempt to produce the material in-house, it was much less of an ordeal than it might have otherwise been.

MG: One obvious byproduct of having art directed both the web site and the on-air material for MTV2 is that the look, feel, and motion of the two projects are a perfect match. Which came first, the site or on-air material?

MN: The web site. From there, it wasn't difficult to repurpose and supplement the Flash animation to suit broadcast standards. As I said, we had excellent support on the project, which made the translation go very smoothly.

MG: Tell me a little of the underlying idea behind the aesthetic. At first glance, it appears to be a sort of music machine, but is there more to it than that?

MN: If I had to describe it, I'd say it is meant to be an abstract environment, populated by the MTV2 community.

MG: I'm always pleased when a project seems to come out of nowhere and make a huge creative impact. Did you expect the overwhelmingly positive reviews and awards received by this project?

MN: As these things go, we are always too busy working on the projects to ever consider how they will be received. So no, we didn't expect anything.

MG: To what do you attribute the universal appeal of these graphics?

MN: I think the graphics have a confidence in their simplicity. They are ambiguous, so the viewer can interpret them as they wish. And they have a sense of humor in their behavior, which helps. Most people respond immediately to humor.

MG: One focus of your work is interface design. Do you find it more frustrating or liberating that current motion graphic design for television lacks this interface component?

MN: I must admit, sometimes it is refreshing not to worry about interface functionality.

MG: Featured here are frames from one of your interface design experiments. The project is called The Typographic Tree and was part of an interactive installation in which participants were encouraged to sing, hum, or otherwise make noise into a microphone. Through this audio interface, the participants could "control" the growth of computer generated mushrooms on a tree stump. How and why was the project conceived?

Project Title: MTV2 ID
Project Type: Ident
Channel/Venue: MTV2/UK
Creative Director: Daljit Singh
Creative Director/Designer: Mickey Stretton
Designers: Brad Smith, Merlin Nation

Daljit Singh: The project comes under the umbrella of our Digitfeed project—www.digitfeed.com—and represents our continuing personal work, which we have always done. We spend between fifteen and twenty percent of our time on R&D projects. The tree was the first manifestation of the Digitfeed project, and demonstrates how we can interact with technology without necessarily touching it.

MG: The Typographic Tree presents a new form of interface, and presents a newer form of animation. Similar to Satori [an early Mac screen saver] or, more currently, iTunes Visual Effects [also for Mac], such projects blur the line between computer code and art. Do you envision a time when the results of creative coding will enjoy the same level of distinction as other fine art genres?

DS: Yes, I do believe this will happen eventually; but I think there is a bigger issue we first must overcome and that is whether design will ever completely be considered fine art. I think that it should be!

MG: It is now possible for designers to work successfully without ever leaving their homes. Still, most creative people prefer to work in small groups. What are the advantages of working collaboratively, as opposed to working alone?

DS: Creative people always need to draw inspiration either from each other or from their environment. So, I believe working in groups or teams is essential to creative growth. There are also times when one needs one's own space in which to think and concentrate, too.

MG: Are most of the Digit team UK natives?

DS: I was born in London. Other Digit members come from Australia, India, Denmark, Germany, USA, Sweden, and Wales.

MG: How do you envision Digit will evolve as a company?

DS: We want to take our experience of interactive design and apply it to physical products. We also want to continue having fun!

MG: Who or what are some of Digit's creative influences?

DS: Fish, natural history, wallpaper, spoons, water, Madhur Jaffrey, and Buckminster Fuller.

Project Title: mtv2.co.uk
Project Type: Web Site
Channel/Venue: Web
Creative Director: Daljit Singh
Creative Director/Designer: Mickey Stretton
Designers: Brad Smith, Merlin Nation

Project Title: The Typographic Tree
Project Type: Experimental
Channel/Venue: Installation
Creative Director: Daljit Singh

3.

>segue

Jakob Trollbäck / Trollbäck & Company / New York, New York USA

Jory Hull / Jory Hull Design / New York, New York USA

Finnegan Spencer / Engine Design / Sydney, Australia

Richard Fenwick / Unified Systems® / London, UK

Jakob Trollbäck / Trollbäck & Company / New York, New York USA

One intriguing feature of the work of Trollbäck & Company is their penchant for drawing inspiration from classic motion graphic design of the 1970s and 1980s. They don't recreate the past, but instead blend a variety of influences and ideas to create original work that is a product of its time. A case in point is the 2 1/2 dimensional pan. Early electronic iterations of this approach first appeared shortly after, and as a direct result of, the introduction of Digital Video Effects (DVE) technology in the early 1980s. These devices made it possible to move a flat plane of video in three-dimensional space, hence the name flat 3D or 2 1/2D.

Melanie Goux: Type is the Achilles heel of many motion graphic designers, but for you, it is a specialty. Type forms are often central elements in your team's work. They are communicative, evocative, set the pace, and drive the transitions within a piece. How did you develop this love affair with type?

Jakob Trollbäck: Most of us here are fascinated by type. Gutenberg made it possible to communicate thoughts, poetry, and fiction to the masses. But later, through design, it became possible to infuse those messages with another layer of content. This is why typography is such a wonderful idea. Type design is also an excellent way to judge new talent. Are they conceptual? Do they understand dynamics? Is their work emotive? Is it beautiful? All these qualities, which are essential for visual communication, can be expressed through type.

MG: What other qualities do you look for when choosing creative people to join the company?

JT: Vision, energy, and social skills. We have a lot of fun together.

MG: I've been surprised to learn some of the most successful designers working today never studied, or only peripherally studied, design. What did you study in college?

JT: My interests were in technology, electronics, and physics. As a student, I built synthesizers and such—dorky indeed. Looking back, I realize what really interested me was the creative process; the ability to create new things from nothing. As for our group, many people here have formal design training, but very few have formal training in motion design.

MG: When did you first become interested in motion graphic design and how did you get started?

JT: My first design project of any kind was creating flyers for a club where I was a DJ. Then, in the late 1980s, I saw the movie The Untouchables twice. Only after seeing it the second time did I realize the movie wasn't really very good, but the titles were so wonderful they had lured me into thinking it was a better movie.

Later (in 1991), I moved to New York, aspiring to be a (print) graphic designer and somehow landed a job at R/Greenberg Associates doing motion design. How this happened, I'm still not sure, but they said my print book looked very filmic. After about a week, I realized that they had done The Untouchables titles. Lucky break.

MG: When did you start Trollbäck & Company?

JT: I worked with many extraordinary people at R/GA, and after seven years there, I felt it was time to be in a position to choose the kind of jobs we took on. Some of us wanted to expand our palette and do a wider variety of projects, which is difficult when you're working for a large company with huge overheads. So, the four best people joined me and that was that.

MG: My current thinking is that business majors should run businesses, and designers should design. You do both. How do you balance the demands of running a successful firm with the need/desire to design?

JT: I always try to be involved in the initial, creative brainstorming phase of each project. And because I don't have time to participate in the whole process, I have the advantage of bringing a fresh eye to the final phase. You could also say I create vicariously through the geniuses I work with.

MG: So you're more engaged with creative direction than hands-on design work these days?

JT: I used to be extremely hands-on before I set out to run a company. Still, I believe it is necessary to stay familiar with the tools in order to maintain a close relationship to the creative process. I miss being completely hands-on and now relieve some of that frustration with a saw, a hammer, and some nails at my summer house.

MG: Speaking of frustration, if you could change one thing about the professional practices of our industry, what would it be?

JT: I think all creative vision is, by definition, at odds with mass appeal. Yet, we have to take on a certain amount of commercial projects in order to maintain a studio large enough to allow us to run exciting and utterly unprofitable projects. This conflict is very apparent when we have to spend precious time just convincing clients we can do each job. In this business, reputation and past performance seem to be irrelevant. Imagine if, let's say, Gerhard Richter had to prove his skills before being commissioned to do every painting. So, I find the whole pitching process we are forced to participate in very tiring.

MG: One technique that appears occasionally in your work is to freeze a frame of video and then quickly evolve it into a more graphic image. Tell me a little about your development of such techniques.

JT: The philosopher C. G. Jung claimed that artists are the prophets of our age, since they see things differently from other people. It's a lofty prospect, but we always try to create new, clever ways to visualize an experience. After all, much of what we do as designers revolves around our ability to see things differently.

MG: How important is music to your design/ animation process? Do you animate to music or find music to suit the animation?

JT: There is a Frank Zappa quote that goes:
 "Information is not knowledge.
 Knowledge is not wisdom.
 Wisdom is not truth.
 Truth is not beauty.
 Beauty is not love.
 Love is not music.
 Music is the best."

I have a lifelong passion for music. I used to have a record store and was a DJ at a club. During that time, I listened to music every second of my waking hours. Eventually, I became a decent designer and later, had decent ideas about motion. But it was not until I personally started working on the Avid that a light went on and I began to consider motion design as choreography. It's the rhythm (or even a rhyme if so choreographed) that makes great motion design. So, in a way, I'm fortunate to be back in the world of music and often dream of having time again to visualize many cuts of music in images and color.

For the majority of our projects, we try to involve musicians as early as possible and always create motion with rhythm and tempo in mind. In addition, we have plans to build an in-house music studio.

MG: How do you most often begin a project? Do you sketch or go directly to the computer?

JT: It depends. We do sketch, but only to explain our thinking to each other during the concept phase. Everybody here is very fast at putting things together on the computer. Often, it is necessary to "consult" with the software to test ideas. However, this is rarely fruitful until we have figured out the conceptual approach.

MG: The American Journey program open created for the Travel Channel is basically an extended pan, or panorama, of American life and culture. The transitions are the most complex feature of the piece. How was this piece developed?

JT: That piece was created by Laurent Fauchere and Antoine Tinguely. It all started with a big white board of images they had assembled to get an overview of the kind of imagery that might be appropriate. We all looked at the board and realized it was, in itself, very beautiful. This led to the idea of a virtual journey across the board that would incorporate stills, live action, and graphic elements that were more iconic representations of America.

We wanted to add depth to the scenes in order to convey a feeling of travel, as if the viewer were looking out of a car, train, or bus window. We did this in two ways. Some photographic images were mapped onto three-dimensional objects but, mostly, source material was separated into discrete layers, that were stacked on the Z axis and moved at varying speeds. This is one of our favorite techniques. Some call it flat 3D, but it's also referred to as 2 1/2 D or 2.5D.

MG: Do you remember the first time you ever saw something you created air on television?

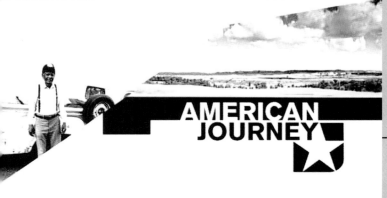

Project Title: American Journey
Project Type: Program Open
Channel/Venue: Travel Channel
Creative Director: Antoine Tinguely, Laurent Fauchere
Design & Animation: Antoine Tinguely, Laurent Fauchere, Chris Haak
Software: Adobe Illustrator, Adobe Photoshop, Adobe AfterEffects,
Lightwave 3D, Maya 3D/Effects, Avid Editing
Hardware: Macintosh, PC, Avid

Sundays 10 pm e/p

JT: I remember the experience, but can't remember the exact piece. Most likely it was nothing more than an end tag for some commercial, but I recall thinking it was pretty cool. I do remember seeing the first film title I worked on for Night Falls on Manhattan. I was with my wife at our local theater and I remember feeling very proud.

MG: Many motion graphic designers fantasize about creating film titles. Is it as interesting as it seems?

JT: There is a strict relationship between creativity and budget, but unfortunately, it's an inverse relationship. Generally, the larger the budget, the lower the tolerance for taking creative risks. But opening titles for feature films can be the exception to this rule. Although the budgets for these projects are smaller than might be expected, they are better than zero and the added benefit is creative freedom.

With film titles, we are actually encouraged to create a totally unique piece—unexpected, cool, and maybe even a bit artistic. This rarely happens with commercial production. For the most part, the marketing people stay out of the process, since by the time the audience sees the titles, they have already bought the tickets. No one is going to decide whether or not to see a film based on the opening titles.

Working on film trailers (or movie promos) is very different and many times more complicated than creating film titles. Movie trailers are a critical sales tool and as such involve teams of marketing people and many, many layers of approval, focus groups, and the like. Besides which, unlike film titles, there is a formula for producing movie trailers that doesn't allow much room for creativity.

MG: Are there other differences between producing animation for television and producing film titles?

JT: One of the best things about creating film titles is, even though it's a minor pain to work with the larger film resolution, you get to see your work on a huge screen, untainted by the ruthless destruction that is the National Television Systems Committee (NTSC). Also, too much work for television is crudely aimed to sell. Most of it lacks vision and fails to recognize that we are, in fact, fabulous creatures that need to think, be inspired, and react in order to be happy. It's sad that so few clients understand that great, memorable advertising is only created by taking chances.

Project Title: A Beautiful Mind
Project Type: Film Titles
Channel/Venue: Cinema Theaters
Creative Directors: Laurent Fauchere, Jakob Trollbäck
Design & Animation: Laurent Fauchere, Chris Haak
Software: Adobe AfterEffects, Lightwave 3D, Maya 3D/Effects, Avid Editing
Hardware: Macintosh, PC, Avid, Cameras

Jory Hull / Jory Hull Design / New York, New York USA

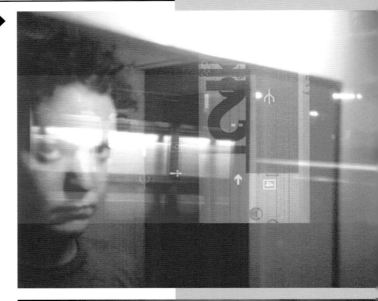

Jory Hull is in transition. Not surprisingly, motion graphic designers working in the white-hot arena of commercial production often experience a high rate of enervation. With few exceptions, our relatively new field of motion graphic design is itself in flux and therefore offers little continuity and few exemplary career paths. By any measure, Jory's career thus far has been a success. Still, he is ready to segue, perhaps to directing, filmmaking or painting, which was his first love.

Melanie Goux: I've always been impressed by how quickly you're able to come up with solutions. You make this look too easy.

Jory Hull: My method of working usually involves experimenting until something hits me. I do a lot of avoiding the problem, but when an idea comes, it comes fast. I've always preferred to back away, to see if there's something behind me, rather than push hard through a problem.

MG: So, it's all about flow?

JH: Yes, something like that.

MG: Do you begin by considering the transition or resolve frames first?

JH: I first consider everything in motion, as if I'm choreographing a film scene, but the storyboards for clients always need to show both. I've found that considering time and motion from the start simplifies the whole production process later.

MG: What's more important in this job, being an able technician or a fluent designer?

JH: It helps to be strong in both, but I feel it's more important to be a designer first, to have a good eye, intuition, process, etc. That said, about ninety percent of my day is spent animating, editing, or otherwise working with files on the computer. So,

Channel Identity

design // •

/ the

/moving/

Project Title: Montage
Project Type: Self Promotion
Channel/Venue: Demo Reel
Creative Director: Jory Hull
Software: Adobe AfterEffects, Adobe Photoshop, Adobe Illustrator
Hardware: G4 Macintosh, Epson Scanner

yes, this is a technical medium, sometimes absurdly so. An architect works in one program to design a building that will last a hundred years. We have to be fluent in six or seven programs running on four or five platforms in order to create a piece that's thirty seconds long and will air for approximately two weeks before it disappears.

MG: Your primary tool is Adobe AfterEffects. Do you envision ever learning to run any high-end systems?

JH: I don't think in terms of high-end or low-end.

It's possible to get interesting and usable effects from almost any piece of software. When I first moved to New York, I was told during a job interview that if I wanted to "make it" in broadcast design, I'd have to learn Quantel systems. That's no longer the case. AfterEffects is my tool of choice now.

I have a working knowledge of other systems, because I also direct Flame sessions, among others. In New York, all Flame suites have specialists who often make more than designers. Few of them have formal design training, but that's not to say they don't have visual talent. In fact, quite the opposite, but it seems to come from a different place.

MG: You enjoy art directing film and video shoots and prefer working loosely and intuitively. How do you reconcile your process with the more rigid production process of most commercial projects?

JH: I try to leave time for experimentation in both the shooting and production schedules, because I'm always looking for the unexpected or accidental in both, but it's difficult. Standard practice requires staying with "the plan." This work isn't art. A great deal of money is spent on commercial production, and so many people are involved that it's very difficult to deviate from a plan unless it can be done quickly. The ability to spot what is and isn't

working and to change direction without wasting time or money is important.

I'm very specific as to what I want visually, but my preference would be to work in a more open-ended way. The problem now is that much creative work is done fast and on spec. As a result, we often end up locked into an idea which would have been much stronger had we been able to include all the new or unexpected things that presented themselves throughout production.

MG: You've produced projects with both large and small budgets, but one of my favorite pieces is from the Nike Presto campaign. I really enjoy the easy spontaneity of those spots.

JH: Those spots were shot, scored, and produced entirely at our studio with DV-Cam and desktop software. We had less than two weeks from concept to delivery, which really narrowed our options considerably.

MG: The main transition technique used throughout the spots is a basic wipe key. How do you keep such a basic device from looking simplistic?

JH: I never rely on just one device. I layer transitions in the same way I layer graphic elements. In the Nike spots, there are multiple wipe keys mixed with dissolves, which are then mixed with quick cuts and so on. This came from throwing the piece back and forth a few times between the editor and myself. The music was also created in-house simultaneously, so we had more flexibility in putting the campaign together. I shot the footage in two hours with some basic props and lights, but then had to treat it quite a bit. If I'm working with excellent film or High Definition Television footage, I respect it more, even though I've found that the higher the footage quality, the better it responds to treatment and effects.

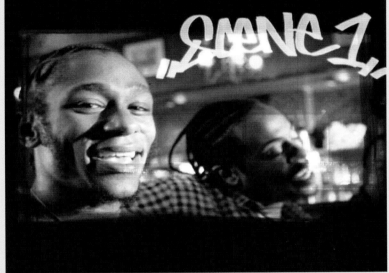

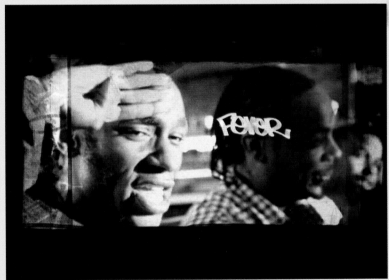

Project Title: Miss Fat Booty
Project Type: Music Video for Mos Def
Channel/Venue: Broadcast
Project Art Director: Jory Hull
Core Creatives: Daniel Fries, Julian Bevan,
Limore Shur at Eyeball NYC
Editor: Tom Dowd

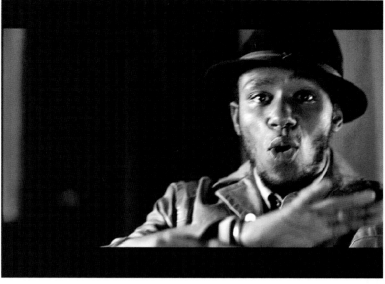

Project Title: OH NO!
Project Type: Music Video for Lyricist Lounge
Channel/Venue: Broadcast
Project Art Director: Jory Hull
Creative Director: Limore Shur
Designers: Rachel Riggs, Tatiana Arocha,
Mario Stipinovich
Editor: Alex Moulton
Created at Eyeball NYC

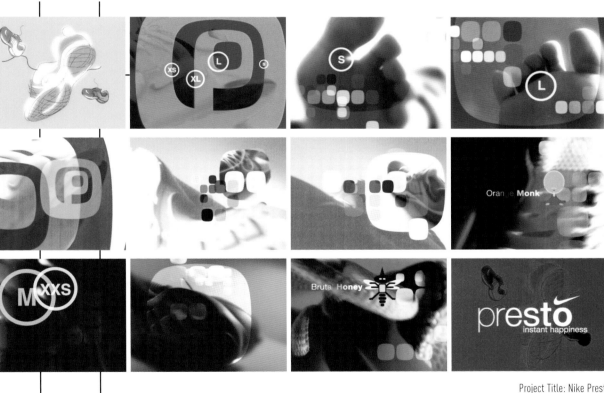

Project Title: Nike Presto
Project Type: Commercial Spot
Channel/Venue: In-store Video
Project Art Director: Jory Hull
Creative Director: Limore Shur
Designer: Tatiana Arocha
Sound Design, Original Music: Alex Moulton
Editor: Michael Palermo
Created at Eyeball NYC

MG: You were able to create a genuinely urban, hip-hop-looking music video for Mos Def, even though this didn't come from your own experience. I understand the artist was very pleased?

JH: It was my design, but I was one of a team of fifteen people working over an insanely tight, three-day production schedule for the video. The project started with Mos Def's original idea of somehow treating footage [footage they had already shot, but were unhappy with] to make it resemble a comic book. We knew this would be difficult to accomplish in three days, so we experimented with a few variations of the idea.

When Mos saw the various tests, he zeroed in on this approach, and said it was "old school." So, yes, he responded to it immediately. As for the urban hip-hop look, it is ubiquitous to anyone my age, so I don't think of it as foreign or as something outside of my experience.

MG: One of the coolest elements of the piece is the constant flow of graffiti lyrics. Here again, you've used a simple, but appropriate solution.

JH: Julian Bevan, a DJ, hand-drew every word, which we then scanned and animated to write on in time with the track. Our goal was to produce something different from the standard, slick, Hype Williams look of so many rap videos. Mos is a critically

Project Title: Eyeball NYC Segments
Project Type: Self Promotion
Channel/Venue: Demo Reel
Project Art Director: Jory Hull
Software: Adobe AfterEffects, Adobe Photoshop,
Adobe Illustrator, 3D Studio Max
Hardware: Sony VX1000 Video Camera, PC

respected artist and we knew the video needed to
have a serious, nostalgic old-school feel, even
though the song is rather comical and lighthearted,
as far as his other work goes.

MG: The video is about an old girlfriend of Mos'?

JH: The song is based on his personal experience
and the video is a very literal interpretation of the
song, the title of which is Ms Fat Booty.

MG: Do you have all the fun? Never mind, don't
answer that.

Finnegan Spencer / Engine Design / Sydney, Australia ▶

Finnegan Spencer is among the last of the self-taught motion graphic designers. Today, it's possible to study motion graphic design in most art colleges and universities around the globe. What once was an obscure craft, populated primarily by engineers and technicians, is now planted firmly in the domain of design. This positive development has helped to raise the profile of, and thus legitimize, our field. The resulting influx of talented designers has been stunning, but pros like Spencer continue to rise above the crowd.

Melanie Goux: How do you generally begin a new project?

Finnegan Spencer: Ideas can come from strange directions, so it varies. It might all start with a sense of motion that leads to constructing elements and a narrative, or alternatively, a logo or font might inspire the process. I don't follow a formula, or argue with the order in which ideas come together, just so long as it all feels right.

MG: Much of your work is somewhat futuristic. What do you envision motion graphics will be like in fifteen to twenty years?

FS: Probably quite outrageous. The tools are already there for anybody to produce amazingly professional motion graphics, and it won't stop there. Just as print designers first capitalized upon, and later lamented, the proliferation of desktop tools, soon we will worry our skills are becoming obsolete. But really, this all just serves to increase the value of talent and good ideas.

I think moving images will become more ubiquitous, eventually replacing many still forms of communication. How people view and interact with these images will likely be determined by how connected they choose to be. From a design standpoint, styles tend to come and go in roughly

Project Title: Ambience
Project Type: Self Promotion
Channel/Venue: Demo Reel
Designer: Finnegan Spencer
Design/Production Company: Ambience
Entertainment
Software: Adobe Photoshop
Hardware: G3 Macintosh, Quantel Hal

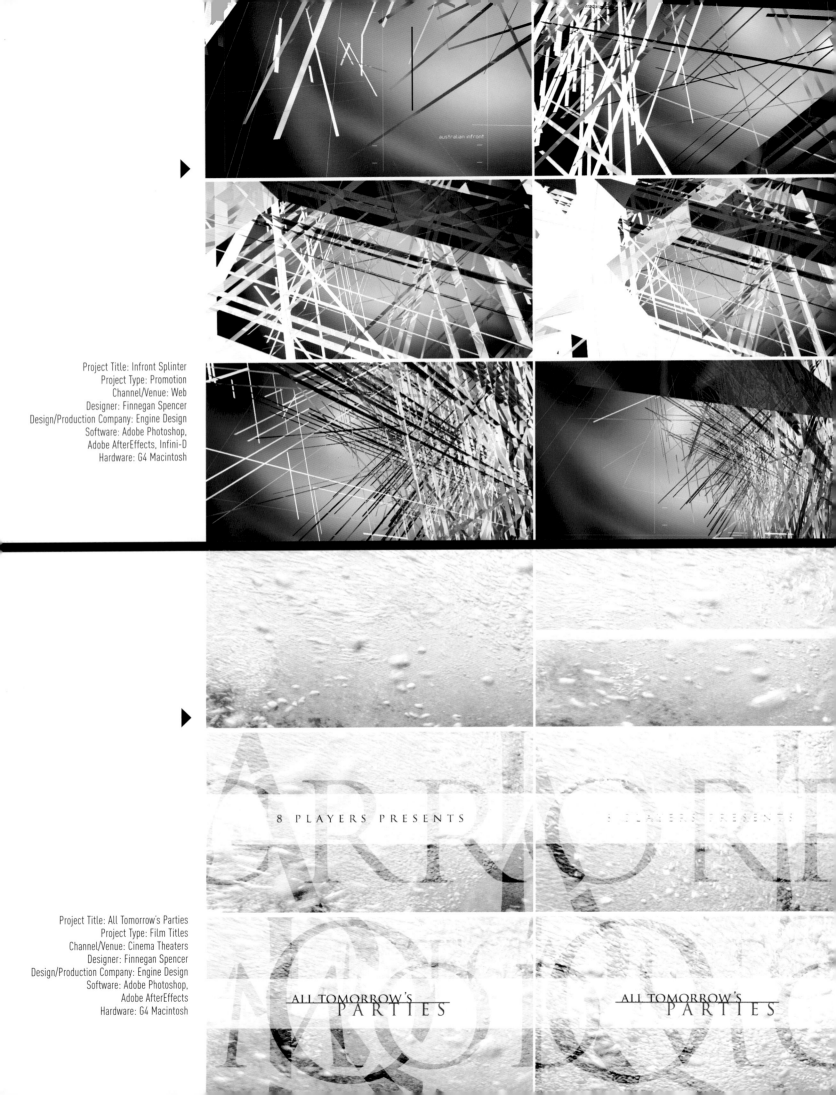

Project Title: Infront Splinter
Project Type: Promotion
Channel/Venue: Web
Designer: Finnegan Spencer
Design/Production Company: Engine Design
Software: Adobe Photoshop,
Adobe AfterEffects, Infini-D
Hardware: G4 Macintosh

Project Title: All Tomorrow's Parties
Project Type: Film Titles
Channel/Venue: Cinema Theaters
Designer: Finnegan Spencer
Design/Production Company: Engine Design
Software: Adobe Photoshop,
Adobe AfterEffects
Hardware: G4 Macintosh

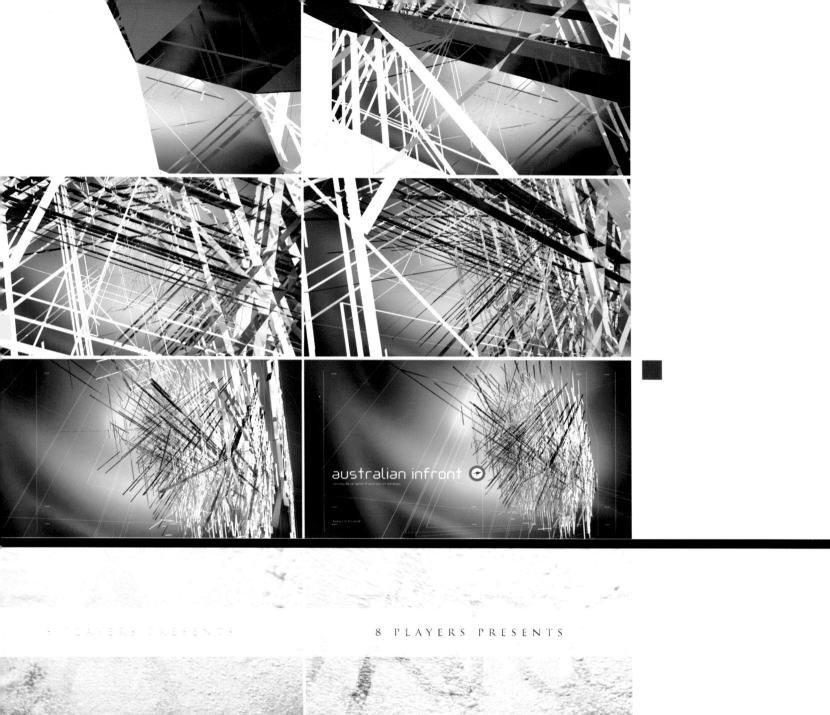

australian infront

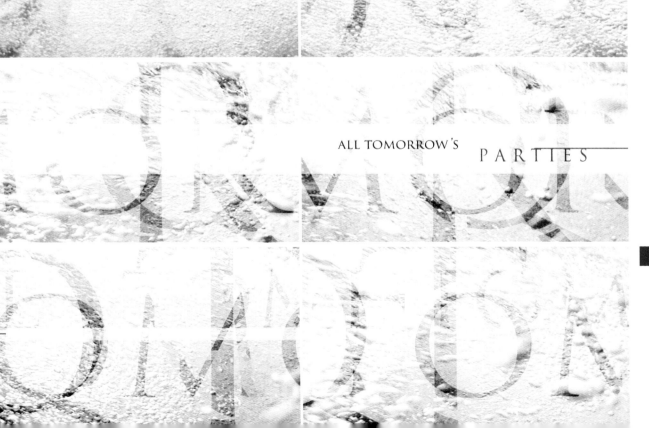

8 PLAYERS PRESENTS

8 PLAYERS PRESENTS

ALL TOMORROW'S PARTIES

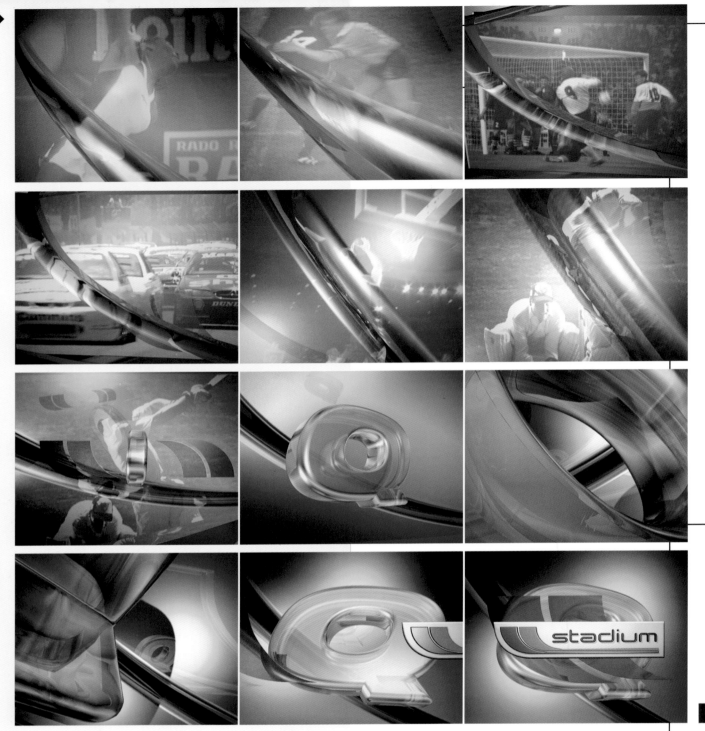

twenty-year cycles, so by 2020, it's safe to assume we will witness a resurgence of the styles prevalent now, but beyond that is really anyone's guess.

MG: Do you make time for personal projects?

FS: All the time. Those projects are the only things that keep me sane. Personal work needs no explanation and, as such, has no limitations. It has become my outlet for all the ideas, outside of client work, that need to be realized in order for me to move forward and onto the next project.

MG: How did you first become interested in motion graphic design?

Project Title: Q Stadium
Project Type: Opening Titles
Channel/Venue: Qantas Inflight Entertainment
Designer: Finnegan Spencer
Editor: Steve Turner
3D Animation: Mick Watson
Flame Artist: Lee Sandiford
Design/Production Company: Engine Design
Software: Adobe Photoshop, Adobe AfterEffects, Maya, Flame
Hardware: G4 Macintosh

SHOCKWAVE FILMS
PRESENT

A JANE TURNER
FILM

RYAN MOORE

KATE DANIELS

SNOWCRASH

FS: Like most designers, I was initially quite fascinated with film titles, and found them just as inspiring as the films they framed, sometimes more so. I studied graphic design in college and occasionally dabbled with motion, but at the time, the hardware and software were both quite limiting, which made it difficult to progress. Still, I remained interested and after a few years of working in print, was hired by a video post-production house, which happened to be in need of a print designer. Once there, I became involved in everything I could. At the time, there was no career path to motion graphics, so I was quite lucky.

MG: Did you have a mentor, or are you self-taught?

Project Title: Snowcrash
Project Type: Experimental
Channel/Venue: Not for Air
Designer: Finnegan Spencer
Design/Production Company: Engine Design
Software: Adobe Photoshop, Adobe AfterEffects
Hardware: G4 Macintosh, Quantel Hal

FS: There have been a handful of amazing people who've taught me the rules and principles of the industry. Their passion for what we do has been contagious. Although these people have helped to give me a technical base, stylistically I've developed my own sensibility.

MG: Are you more of a hands-on designer, or do you tend to direct others?

FS: It is always wonderful to work with people who both enjoy and are good at what they do, but I don't think you can beat using your own hands. The difference between the two could be compared to playing an instrument versus conducting an orchestra, and for me there is no contest. Creating new things with my own hands is a large part of what I enjoy about this work.

MG: You've produced a number of pieces for High Definition Television (HDTV) and also for large-format film output. How does your working process change for these projects?

FS: The first and most obvious difference isn't aspect, but file size. The larger the file size, the slower the entire production process. Therefore, all our research and development for large format projects is done at much lower resolutions. Although the finished piece sometimes has to be completely recreated before proceeding to final output, we find this saves time in the end.

MG: What is the strangest and/or most unexpected thing that has ever happened to you while producing a project?

FS: Discovering that my wife likes red.

Project Title: Infront Spirals
Project Type: Self Promotion
Channel/Venue: Not for Air
Designer: Finnegan Spencer
Design/Production Company: Engine Design
Software: Adobe AfterEffects
Hardware: G4 Macintosh

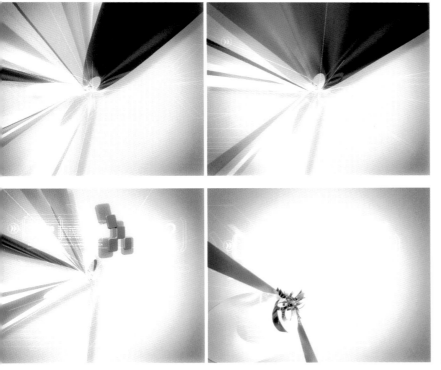

Project Title: Engine
Project Type: Self Promotion
Channel/Venue: Demo Reel
Designer: Finnegan Spencer
Design/Production Company: Engine Design
Software: Adobe Photoshop, Adobe AfterEffects, Infini-D
Hardware: G4 Macintosh, Quantel Henry

Richard Fenwick / Unified Systems® / London, UK

Fenwick's work, like other new forms of digital art, challenges the notion of art as commodity. Future acceptance of these new art forms will require, to a large extent, a redefinition of the business of fine art. Museums, galleries, collectors and patrons alike have traditionally relied on the notion of a single original, or in the case of printmaking and photography, a single source, to define value. Huge sums paid for rare works have fueled the art economy. However, digital art has no such reproduction boundaries, and as such, is considered somewhat disposable by many members of the art establishment. We may one day learn to value art not for its rarity and monetary worth, but for its meaning to society, and digital art has the potential to engender this shift.

Project Title: RND# 91/51st State®
Project Type: Experimental
Channel/Venue: Gallery Screenings
Designer/Director: Richard Fenwick

Melanie Goux: In addition to producing commercial projects and music videos, you also create more experimental, longer-form pieces. As one of only a few people exploring the relatively new genre of "graphic filmmaking," has it been difficult to pursue given the shortage of venues, or for that matter, predecessors?

Richard Fenwick: Well, it hasn't been difficult to pursue since (rightly or wrongly) many people perceive different as good. Working in a relatively new genre can get people very excited about whatever you're working on, which opens doors.

The lack of predecessors is also something of a benefit because there are few preconceptions bestowed upon you. Unfortunately, for the same reason, people often seem reluctant to express an opinion. It is as if they don't really know what to say, most likely because they have no previous reference point from which to gauge your work.

MG: What is the difference between graphic films and fine art films? Are they one and the same?

RF: I don't really make a distinction between the two. My feeling is that any work created to suit the purpose of the artist, rather than the purpose of others, should be considered art. That said, a graphic film is perhaps best described as a piece that blends loose narrative with graphic elements.

MG: In the piece 51st State, you investigate the actual location and nature of the Internet. The audio begins with a man seeking advice from befuddled tech-support people, via telephone, about buying a piece of the Internet, as if it were a piece of real estate. These are actual recordings, not scripted, and it's a funny piece. How important is humor to your work generally?

RF: Observational humor is very important to me. Humor is almost always inherent within a

Project Title: RND#6/Underworld®
Project Type: Experimental
Channel/Venue: Gallery Screenings
Designer/Director: Richard Fenwick

situation—sometimes it is overt, sometimes disguised. Either way, I like to find this type of humor, but it's important not to force it. I might sometimes enhance it but I try not to build it in unnecessarily.

MG: Unified Systems® isn't a company really, but the name given to your web site (www.richardfenwick.com). Will it ever become a place or a piece of real estate not unlike the ideas explored in 51st State?

RF: Yes, it might become real one day. At present it is basically just an umbrella name to house everything I'm involved with, sort of a common brand. As long as it remains small and manageable, it need not move outside the realm of the web. Currently, it's a one-stop guide to what I'm up to.

MG: The short film In At The Beep End contains the phrase, "You can't fake it, you either have it or you don't." How did you find your own creative voice? Have ideas always come easily to you?

RF: Yes, I do think it is pretty difficult to fake it and although it may be unfair, I think we're either born with an inclination to be creative or we're not. On the subject of ideas, they never come easily to me. I seem to be motivated by deadlines, so it's almost always the eleventh hour of the night before!

MG: Do you wait until the ideas are fully formed in your mind before sitting down to produce a project, or do you work as you go?

RF: This usually depends on whether or not clients are involved, since clients always require reassurance as to what they are paying for prior to production. However, with my experimental work, I'm not so structured and, in most cases, I will develop or modify ideas as I work. The two are very different: one is forced premonition (or being visionary), and the other is pure intuition. Both approaches work, and both have their merits—the first is very disciplined and the latter relaxing.

MG: Can you recall the first time you ever saw something you produced on television?

RF: Yes. I had a few things first air at about the same time in 1998, which was both exciting and nerve-racking. An identity I had created for a film channel (FilmFour, UK) and my first experimental opus, States_, went out in the same month. I just remember being mortified that my work was now totally out of my control and defenceless; lost somewhere in the public domain. Happily, I'm over that now!

MG: Several pieces of your most recent series RND#, deal with the idea of man being at odds or overwhelmed by the technology and systems he's created. Has this been your experience in life?

RF: Yes, I'd say I have a love/hate relationship with technology. The more I get involved with it, the more inclined I am to comment on its flaws.

MG: Is the topic of technology a current or consistent theme in your work?

RF: Currently, it is high on my agenda because it is the theme for the RND# series. But this project was born out of a specific time and a desire to start a debate. Once it's finished, I might never return to the subject again.

MG: Much of your work has a voyeuristic or hidden camera quality, and both video and audio are often clandestinely recorded. What is it about this 'surveillance' approach that appeals to you?

RF: I think most directors are voyeurs. With my experimental work, I watch, listen, and record people, partially because I want authenticity [the RND# films are mostly concerned with finding truthful answers] and partially because I want to gain insight into how people deal with situations. I might eventually distill these truisms, these things I've observed, into scripts for other projects.

MG: How have you noticed your own creative process evolve over time?

RF: For me, it's been a highly visible evolution because I've covered a lot of ground in the last five years. I've moved from client-based motion graphics to narrative-based graphic filmmaking, to live action and scriptwriting. Ideas have been a constant throughout, but the methods in which I've wanted, or needed, to convey them have varied greatly.

MG: Most commercial designers aren't concerned with content. Generally speaking, our task is often to illustrate or package someone else's ideas. We don't set the agenda, but instead, set the tone. Is the ability to control content the main reason you produce graphic films?

RF: It's the main reason I do anything. I'm motivated by ideas first and foremost. I make music videos because I enjoy developing the ideas, conversely this is why I'm not too interested in directing commercials. I make the RND# films for the same reasons. I'm also initiating scripts in hopes I might avoid becoming a hired gun style director in the coming years.

MG: You began your career at Static2358 and in 1998 formed OS2. Are you currently involved with a company or group? If not, might you be again?

RF: Yes, I'm currently on the roster of directors at Godman Productions, UK, and I do my experimental and graphic work through my own studio called ref:pnt (reference point), UK. I also have a script writing initiative called BASIC*.

MG: Do you prefer working as part of a team or working alone?

RF: Conceptually I prefer working alone, however filmmaking, as a rule, is almost always a group endeavor. And I enjoy the influx of energy and debate that comes from the production process.

Project Title: In at the Beep End/P. P. Roy®
Project Type: Experimental
Channel/Venue: Gallery Screenings
Designer/Director: Richard Fenwick

Fig. 12.3 Ghia Facia

MG: Is nurturing one's own image and career more important than subordinating one's identity to a company or firm? What are the benefits of individual versus company recognition?

RF: As a survivor of three ways (working for a company, co-owning a company and being an individual), I definitely prefer where I am now; mainly because I've never come across anyone yet that has exactly the same (or even a similar) agenda to my own. And when you don't share the beliefs of the people around you, you waste a lot of time. Fundamentally, as an individual, I do whatever I want everyday. And for a creative person, that is a priceless situation.

YOU

4.

>flux

Bill Bergeron, Greg Duncan / Verb / New York, New York USA

Fabrice Gueneau / Dream On / Paris, France

Violet Suk, Martin Koch / Suk&Koch / New York, New York USA

Thomas Chou / Channel [V] / Hong Kong, China

Bill Bergeron, Greg Duncan / Verb / New York, New York USA

In recent years, there has been much hand wringing and nervous commentary about the efficacy of design. If there is an argument to counter the contention that beautiful design is vapid or that broadcast design is an oxymoron, the work of Verb is exhibit A. These pieces, created for the modest purpose of packaging a cable channel, improve the visual landscape.

Melanie Goux: I'm almost obsessively fond of the interstitial elements you produced last year for HBO. They are some of the clearest, most straightforward and most fluent pieces of motion graphic design work I've ever seen on air. Has the response to this project been overwhelmingly positive?

Bill Bergeron/Greg Duncan: All of the feedback we've received about the HBO Building Blocks has been consistently laudatory. Comments have ranged from, "I've never seen anything like it before," to "It should be the network identity." But, I have to say, compared to the old days, we receive comparatively little feedback from the outside world about our work. It's amazing how, over the last few years,

we've gravitated from an environment where we interacted weekly with clients and peers in the post-house scene, to a world where we work with producers we've never met. We do all of our work—design, animation, editorial—in-house, and communicate with clients via telephone, e-mail, File Transfer Protocol, and messenger. It's obviously more efficient (and cheaper) than the old days, but I really miss the days of hobnobbing with industry types while waiting for the Flame to render. I think this shift in process explains a lot about a general lack of feedback. But, to be fair, we also have yet to get our public relations engine up and running, so nobody really knows much about us. But I can say that we are very proud of the Building Blocks package, and compliment each other frequently on a job well done.

MG: I can usually determine how a piece was produced by the telltale signs left from specific software and/or hardware. The HBO project has no such "thumb prints." Was it produced on multiple devices?

BB/GD: The Building Blocks elements were actually designed and animated exclusively in AfterEffects. It's difficult to detail the actual construction of the project even when you're looking at the open file on the screen, so I'll try to describe the method in broad terms. At the core of the design are a series of lines (or liquid streaks), designed in Illustrator and laid out to correspond to a type descriptor such as "next" or "this weekend." If you look at the original artwork for the streaks, they appear to roughly gradate in lightness from the brightest in the center to dark gray at the edge. The gradation allows the layer to be used as a luma matte that doesn't create a hard graphic edge. We created the streaks very large, so that we could look at them from a long way away in dimensional space, and then luma matted extra-groovy liquid footage to them. We created multiple layers of the streaks and type in 3D space to push the sense of depth and create a sort of echo for the design. The type build happens independently in AfterEffects, using different animations to lock the type into place. We then threw the whole thing into a camera and tweaked the focus and depth of field to move the eye around at different points in the animation.

MG: Bill's formal training is in fine art, Greg studied philosophy prior to working as a typesetter. Did either of you ever envision being neck deep in high-end technology on a daily basis?

BB/GD: No. We didn't envision being broadcast designers. It seems to have happened because we both had an eye for graphics, a love of film and animation, and a penchant for technology. We always try to keep an eye on the artistic and the philosophical, and are constantly looking for ways to infuse our careers with our first loves.

MG: How, when, and why did the two of you decide to form Verb?

GD: Bill and I had been working together as freelancers for several years in a sort of tag-team way. I would often design a project and Bill would animate, edit, and finish it. We lived in the same building in the East Village (New York) and as the projects became larger and larger, the equipment began to proliferate. Near the end of 1999, we bought a Beta deck and Ethernetted our apartments together. At that point, while gazing proudly at our

Project Title: HBO
Project Type: Idents
Channel/Venue: HBO/HBO2 Channels
Art Director: Greg Duncan
Design & Animation: Bill Bergeron, Greg Duncan
Project Supervisor: Marc Rosenberg, VP, HBO On-Air Brand Image
Creative Director: Karen Sands, HBO On-Air Brand Image
Software: Adobe AfterEffects, Adobe Illustrator
Hardware: G4 Macintosh

networking efforts, our wives pulled out the proverbial plug and suggested we find more space elsewhere. The seed was planted, none too subtly. But we also had a desire to graduate to a more mature creative process. As a freelancer, you have a tendency to be a hired gun, brought in to a project too late to add much creatively, but relied upon to fix problems that you weren't responsible for. We needed more creative and technological control to be able to produce the kind of work we wanted. So we found a space in Tribeca (also in New York) and set up Verb.

MG: Many designers fantasize about launching their own firms, but few actually make the leap. Those who do often find it more difficult than rewarding. What's been the biggest surprise so far, for each of you, about running your own shop?

GD: My biggest surprise about running a firm is how little time is actually spent doing design. So much effort needs to go into the administrative side, as well as the marketing and public relations (PR) that it actually feels fresh when I get to sit down and create. One of our goals, as is probably the goal of many design firms, is to figure out how to spend more time designing and less time deciphering missives from the taxman. I think we're also both a little surprised by how much overhead is created by being incorporated versus just running a business as an independent contractor.

BB: I never really anticipated that the identity of our company would form into a palpable force. The Verb concept, the personalities that lead the company, the talent that works here, and the work itself all

have a positive, reciprocal effect that is larger than any of its parts. The overall effect plays out as a good vibe that influences all of us who work here.

MG: In addition to motion graphic design, Verb specializes in interactive, identity/print, and installation design. Which areas do you find most interesting?

BB/GD: We both love architecture: interiors, spaces, installations. Projects that allow us to think creatively about an overall user experience—the scale, the lighting, the audio—really pique our interest. Multimedia installations always provide unusual challenges—how to design for super-wide aspect ratios, how to engineer video to run

seamlessly across multiple monitors, designing video to play vertically or across a sixty-foot-wide screen. It's fun to think outside the traditional parameters of 4:3.

Project Title: Building Blocks
Project Type: Program Open
Channel/Venue: HBO Channel
Art Director: Greg Duncan
Designers: Bill Bergeron, Greg Duncan
Animator: Bill Bergeron
Project Supervisor: Marc Rosenberg, VP, HBO On-Air Brand Image
Creative Director: Karen Sands, HBO On-Air Brand Image
Software: Adobe AfterEffects, Adobe Illustrator
Hardware: G4 Macintosh

Fabrice Gueneau / Dream On / Paris, France

It is always refreshing, especially in this tech-heavy field, to encounter graphic design that speaks to a higher common denominator of intelligence. When I come across work that respects the viewer by offering up ideas rather than the latest video pyrotechnics, it always inspires me. When the ideas are executed with taste and style it is a real joy. Dream On creates such work. Seeing their work underlines the notion that we as designers have only begun to scratch the surface of the potential in this nascent field. It also reminds me how powerful, remarkable and satisfying this form of communication can be.

James Houff: Your pieces featured here are each unique in their vision. However, they exhibit a shared quality or sensibility. Can you articulate what you strive for in your work that might create this shared quality?

Fabrice Gueneau: We strive for a certain rigor at Dream On. We want to go beyond the fashion phenomenon, by creating images that touch people, images that are true to the topic. Our starting point is always the idea. We want to make sense.

JH: You seem to have a strong appreciation of photography. How has that developed?

FG: Actually, Dream On has a strong appreciation for image in general. The agency has a special positioning. We are a design agency specializing in publishing (print), broadcast design, and advertising. The common denominator between the various disciplines is image. Our creative team is often working on very different projects that nourish creativity and a sense of image.

JH: What type of training or education did you have prior to entering this field?

FG: Before I started Dream On, I had been working for ten years in various fields: product design, press, advertising, and broadcast design. My objective was to bring these fields together within a single agency. So, I teamed up with competent people from various backgrounds: graphic designers, photographers, typographers, film directors, artistic directors. This alchemy creates Dream On's fastidiousness about image quality.

JH: Do you work with post houses or do you do all the animating yourself on the desktop?

FG: We produce almost all our work in-house, and we try to keep it in-house as much as possible. We rarely work with post houses.

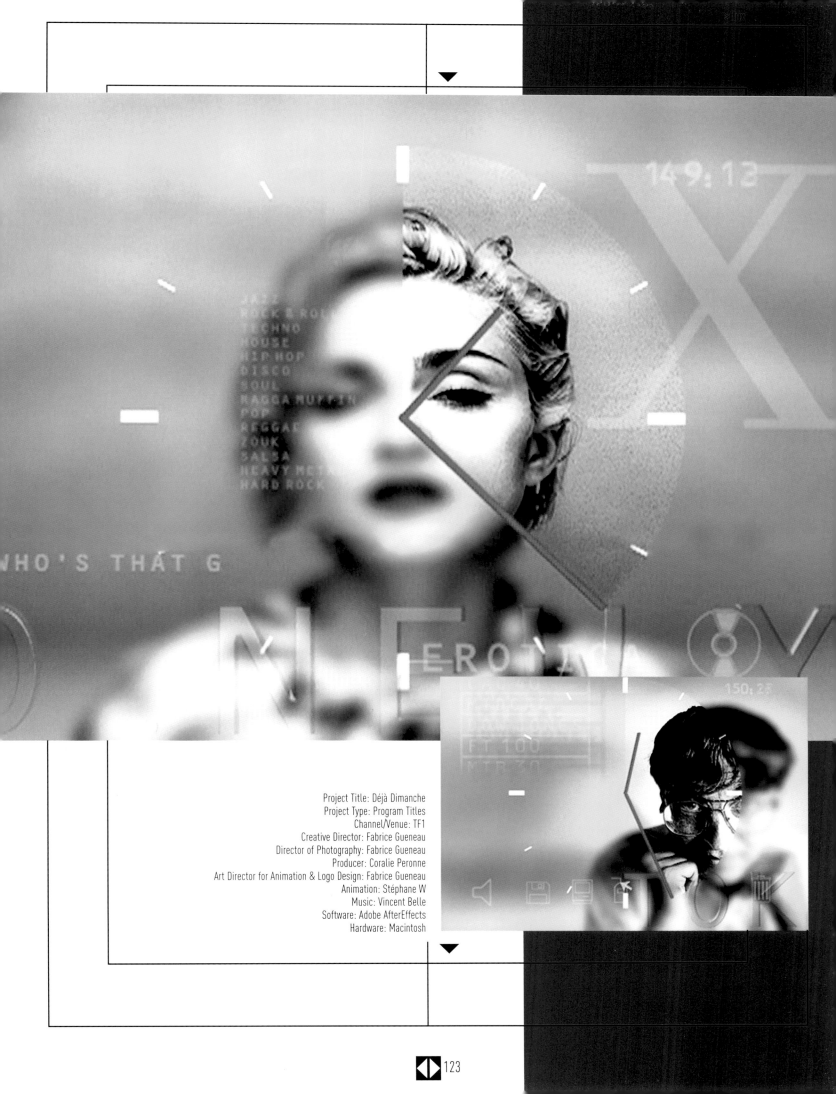

JAZZ
ROCK & ROLL
TECHNO
HOUSE
HIP HOP
DISCO
SOUL
RAGGA MUFFIN
POP
REGGAE
ZOUK
SALSA
HEAVY METAL
HARD ROCK

WHO'S THAT G

Project Title: Déjà Dimanche
Project Type: Program Titles
Channel/Venue: TF1
Creative Director: Fabrice Gueneau
Director of Photography: Fabrice Gueneau
Producer: Coralie Peronne
Art Director for Animation & Logo Design: Fabrice Gueneau
Animation: Stéphane W
Music: Vincent Belle
Software: Adobe AfterEffects
Hardware: Macintosh

JH: What programs do you personally utilize?

FG: We usually work with basic graphic software. We most often use Adobe AfterEffects, working with a full-time AfterEffects specialist. Our technical means are very straightforward. Artistic creation always takes priority over technical performance.

JH: Tell me about the Déjà Dimanche project. What message were you trying to put across?

FG: This title sequence was created for a weekly Sunday evening program, on TF1 [most watched television channel in France]. The program aims to tackle current affairs, with special guests, relevant to the topics at hand. The title sequence showed the virtual dial of a clock, whose hand goes back a week in time (seven by twenty-four hours).

We chose to feature famous people who best represented the issues raised in the program (top model Elle McPherson, literature writer Françoise Sagan, businessman Bill Gates, popstar Madonna, etc). A process of blurry versus sharp was used to convey continuation, together with key ideas appearing and disappearing.

JH: Maybe you could tell us a little about how a project is approached at your office?

FG: Usually, we brainstorm each time we have a brief. We work with many people with different skills. Each one of us is inspired by our individual specialty. The objective is to mix different styles of approach in order to come up with the idea.

JH: Do you feel there is anything particular to the French culture that influences your work?

FG: I am French. I am obviously influenced by my culture and my country. Moreover, I live in Paris, a very dynamic city in terms of art, and I try to get inspired by my background. Nevertheless, it is not true to think that a French cultural exception exists. We are very interested in, and open-minded about the rest of the world. It is true here as it is everywhere else, that some people have taste and some don't.

JH: Are there examples of motion graphic design that you have seen that you particularly appreciate?

FG: I appreciate many different things but there are agencies whose work I really like, for example Tomato (UK), who did the design for the film Trainspotting, Michel Gondry, Me Company (both UK), and Kesselskramer (Holland). I admire them for their innovation and taste in motion graphic design. I appreciate their work especially because they invent things; they don't try to follow trends.

JH: Is there any culture or country that you feel sets the pace in the field of motion graphic design?

FG: There is nice work everywhere if you take time to look. Anglo-Saxon countries like Holland, Great Britain or Denmark have interesting graphic cultures. I appreciate the Japanese way of revisiting pop art.

JH: What are some of your personal inspirations?

FG: I try to go to as many art exhibitions as possible, to watch as many movies as possible and I buy a lot of graphic design books. I also meet a lot of people from my field of activity. I love to travel around the world and I often go to London and New York. All these things keep me inspired.

JH: Tell me about your work for Festival. What were you attempting to communicate with this piece?

FG: Festival, a Francophone cinematic and fictional channel [core target audience forty plus], wanted to freshen up and modernize its image. We chose to humanize the channel by giving the viewer the

programs' diversity, we showed different viewers' reactions while they are watching the channel, which evoked contemporary attitudes to cinema.

JH: What about your work for L'Équipe TV?

FG: We wanted to give more importance to feelings and sensations on L'Équipe TV, a sports information channel. The design concentrates on the essence of sport: deciphering information as well as trying to share sensations. We focused on sport moments, lived from the inside and/or outside.

JH: Are there schools in France that teach motion graphic design?

FG: The Penningen School of Graphic Design is very famous in Paris. I usually recruit graphic designers from there. There is also an excellent school of motion graphic design in Paris called L'École des Gobelins. American agencies frequently recruit students from there.

JH: What advice would you give young people who are trying to enter the field?

FG: I think what is missing today is people who try to innovate. Instead, most follow the trends. I meet many designers who just follow others and create nothing new. Young people must have the ambition to initiate rather than follow. They must listen, watch, and nourish themselves with what is around them. This is what will develop their own creative personalities.

JH: I find that one needs to be versed in many areas to produce outstanding motion graphic design work. The tools are available to allow one person to do it all. Do you feel that the best work comes from an individual or from a team of specialists?

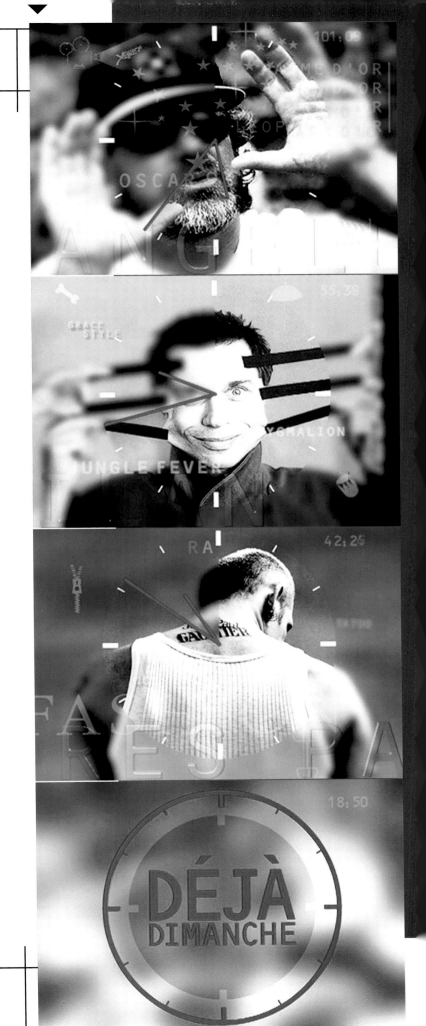

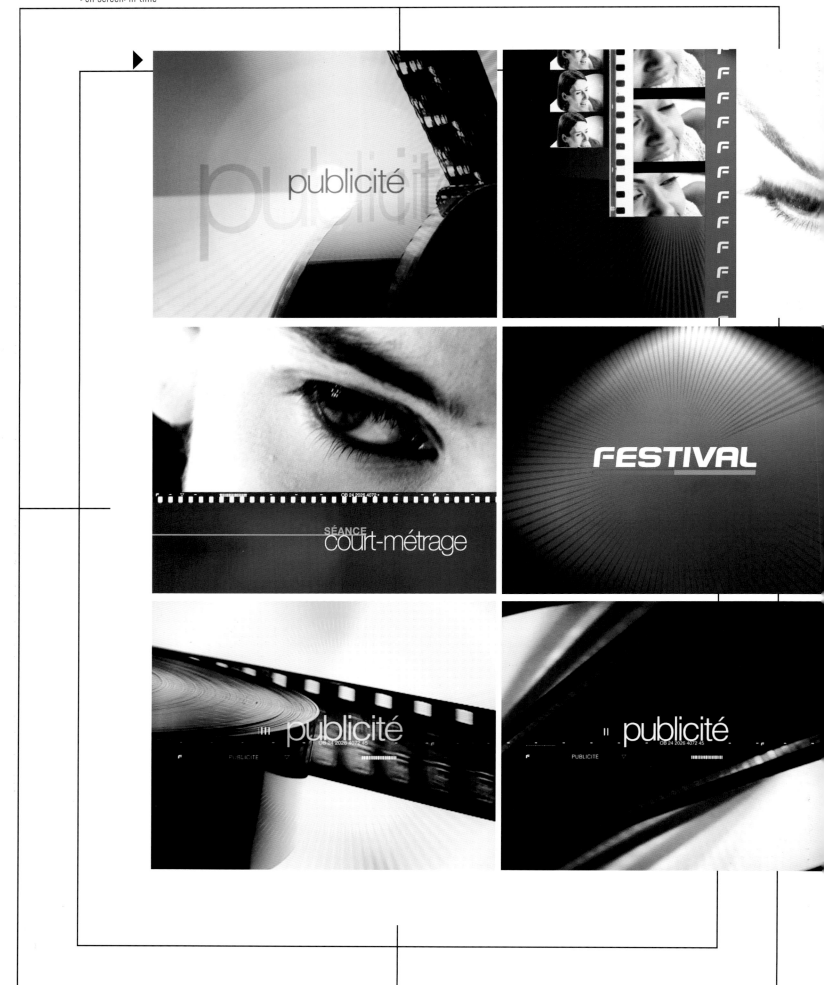

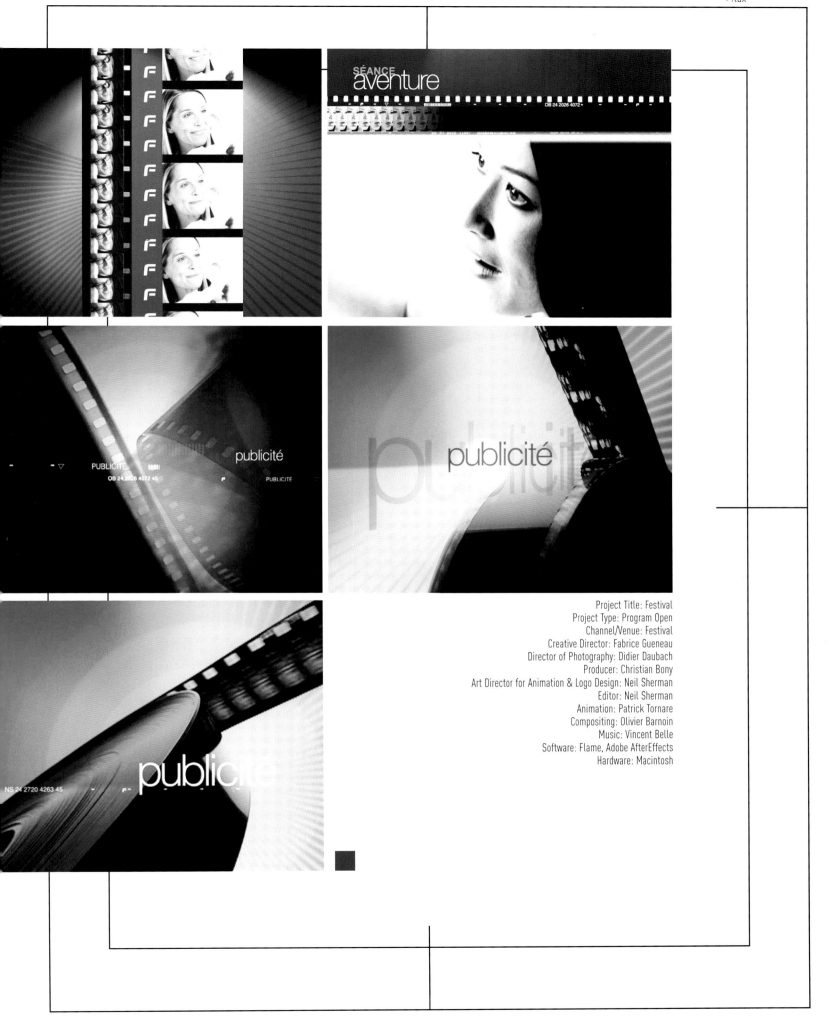

Project Title: Festival
Project Type: Program Open
Channel/Venue: Festival
Creative Director: Fabrice Gueneau
Director of Photography: Didier Daubach
Producer: Christian Bony
Art Director for Animation & Logo Design: Neil Sherman
Editor: Neil Sherman
Animation: Patrick Tornare
Compositing: Olivier Barnoin
Music: Vincent Belle
Software: Flame, Adobe AfterEffects
Hardware: Macintosh

FG: There is no rule. In a team, the good thing is that you get many different ingredients to nourish a project. Although the difficulty is to put people together, and get them to work efficiently and nicely as a team. On the other hand, I've met people who have had a certain experience that allowed them to be creative and skilled enough to do it all, but still, it is uncommon.

JH: How sophisticated are your clients when it comes to this work? What are they asking for? Do you need to do a lot of educating, or are they open to creative work?

FG: In France, we have to spend a lot of time and effort educating our clients. We have to do it all the time. We don't often have the right person in front of us to talk about motion graphic design. The main

reason is that France is still young in the video industry. It took us twenty years to go from three television channels to 150 channels today. It takes a long time to evolve.

JH: Where do you see this field headed in the near future and in the long term?

FG: Technological performance influences a lot of trends in motion graphic design. I think that the field will always be a laboratory. Personally, from an artistic point of view, I hope that we'll return to simple and pure expressions that make sense. I hope that we'll go back to ideas instead of exaggerated special effects. That is why I especially respect Michel Gondry. He experiments but he always has a strong idea. The form is there only to support the concept. support the concept.

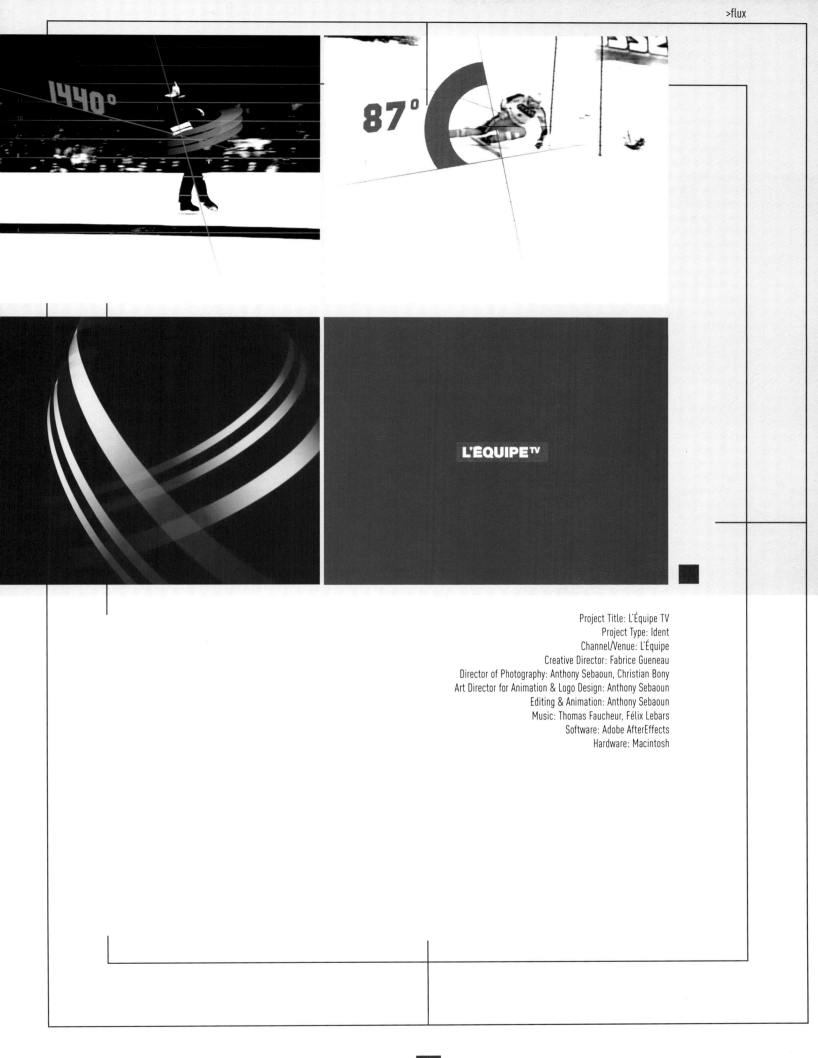

Project Title: L'Équipe TV
Project Type: Ident
Channel/Venue: L'Équipe
Creative Director: Fabrice Gueneau
Director of Photography: Anthony Sebaoun, Christian Bony
Art Director for Animation & Logo Design: Anthony Sebaoun
Editing & Animation: Anthony Sebaoun
Music: Thomas Faucheur, Félix Lebars
Software: Adobe AfterEffects
Hardware: Macintosh

Violet Suk, Martin Koch / Suk&Koch / New York, New York USA

There are a fortunate few who find partners with which to share their creative lives. Violet Suk and Martin Koch are two of the lucky ones. Their talents complement each other perfectly to produce work collaboratively that is stronger than either could produce alone. Indeed, they flow together so seamlessly it is difficult to tell where one ends and the other begins. And although they may be a team, their work always has a singular, clear vision.

Melanie Goux: How did Suk&Koch first meet?

Martin Koch: We met in 1992 at a music video shoot for a techno/industrial band named Dependance. At the time, we were both studying media design at the University of Applied Arts in Vienna. I was directing the music video and Violet was performing in the band. At this shoot we discovered our common interests in Japanese animation, Hong Kong cinema, French comic books, electronic music, and Eastern European animation.

Violet Suk: Shortly afterwards, we began to collaborate on video installations and performances for art exhibitions in Vienna and Berlin, and produced some spec station idents for MTV Europe.

MG: Are you both from Austria originally?

MK: Yes, I was born in Austria.

VS: I was born in Seoul, Korea. When I was fifteen, my family moved to Vienna. A few years later, when my parents returned to Korea, I decided to stay in Austria to study. I ended up staying twelve years.

Project Title: Suk&Koch Demo Reel Open
Product Type: Self Promotion
Channel/Venue: Demo Reel
Director, Producer, Sound, Music, Design: Suk&Koch
Actor: Kim Min

MG: How did you first become interested in producing motion graphics?

MK: We always had an affinity for combining different media in our live action work to enhance traditional storytelling. We first began to explore motion graphics, mainly typography, within music videos, commercials and live video mix performances in the early 1990s.

MG: When and why did you decide to move to New York City?

MK: I've always felt at home in New York with its fast pace and multicultural influences. I had lived here for a couple of months in the early 1990s, during the year Violet studied at the Film/Video Program at Cooper Union (New York).

VS: Since then we visited for one or two months every year to refill our creative batteries. The final move happened in 1998.

MG: Do you collaborate on every project?

MK: Yes we do, especially in the concept phase, although our individual focus changes slightly with each project. For example, during a live action shoot, one of us might focus on the performance and work with the actors, while the other might concentrate on the visual storytelling and work with the Director of Photography (DP) on camera framing and movement.

VS: Recently, in our live action projects, I have tended to work more with the actors, since one of my current interests is performing arts. Martin tends to concentrate on the visual aspects of camerawork and art direction. During the design phase of the projects, we also collaborate in a similar fashion. Together, we conceptualize a piece and assign ourselves different aspects to visualize and work through.

MG: Commercial projects are just one aspect of your

work. You have also managed to produce a large body of personal and experimental pieces, and are actively involved in global film festivals and shows. How do you find time for all of this?

MK: We try to work at least a quarter of the year on R&D projects such as self-produced, original content, short films. In order to have the ability to allocate time for these projects, we keep our business overheads down to a minimum. Also, because of our low overheads, we have the luxury of being able to turn down unchallenging work.

MG: Partially due to the pace and pressures associated with our business, burnout is an almost

chronic problem. So far, this doesn't seem to have troubled either of you. Do you believe that producing these personal or more experimental projects has kept you creatively healthy?

MK: Yes, definitely. An important aspect of staying fresh and avoiding burnout is to find a balance between commissioned work and independent work.

VS: Another important part is to work and experiment with different media formats. We try to alternate between music videos, promos, commercials, video live mix, art exhibitions, broadcast idents, music, and short films as creative outlets.

Project Title: Exposure
Project Type: Program Promotion
Channel/Venue: SciFi Channel
Director, Art Director, Production Design: Suk&Koch
Design: Eddie Shim
3D Artist: Cary Janks
Inferno Artist: Derek Fieney
Editor: John Knauer
Sound Design: Brian Rund
Fashion Designer: David Dalrymple
From SciFi Channel:
Producer/Writer: Ron Buse
Supervising Producer: John Werner
Executive Producer: Josh Greenberg
Creative Director On-Air Marketing: Alex Terapane
Director of Photography: Peter Trilling
Assistant Director: Luis Cublio

MG: The Exposure promo for the SciFi Channel (USA) features a futuristic Lisa Marie [the American actress] kicking butt and presumably saving the city from evil. The look and pace of the visuals plays perfectly to the content. Does your approach change radically for each project or do you have a collection of solutions that constitute a Suk&Koch look?

VS: We do have a highly stylized visual sensibility in our live action work. It's a look we call "hyper-reality" and it stems from the manipulation of

colors to heighten the emotional impact of scenes. Our frequently utilized combination of live action and virtual sets also contributes to this stylized look. Even so, our work is always content specific and we develop the visual and audio style simultaneously from the beginning. Working this way allows us to merge the content and execution more seamlessly.

MG: The Lisa Marie piece is a fairly elaborate production. Was it as difficult and/or challenging to produce as it appears?

Project Title: Origami
Project Type: Idents
Channel/Venue: SheTV Channel, Japan
Director, Executive Producer, Creative Director,
Design: Suk&Koch

MK: By far the most challenging aspect of the project was the shooting schedule. We only had one day to shoot all the live action and we needed to cover many elaborate scenes and lighting setups. To stay on schedule, we had to lose two shots from our storyboard during the course of the shoot. We worked around this by combining the performances in these two lost shots with the action of subsequent shots.

VS: Another challenge was the fight scene between Lisa Marie and her antagonist. For scheduling

reasons, we did not have a rehearsal day to develop the fight choreography prior to the shoot. But thanks to Lisa's background as a dancer and our martial arts fight choreographer, Antonio Tomahawk, we were able to feverishly develop a condensed fight routine in a short time during the shoot. By contrast, we had three weeks to complete the post-production.

MG: At the other end of the spectrum are the interstitial elements you created for the Japanese

women's channel, SheTV, which are whimsical, loose, and intimate. Tell us about their creation.

MK: Yes, the origami idents were conceptually very different from the cinematic SciFi Lisa Marie promo. The idents started out as pure graphic pieces but we subsequently felt that an organic, human connection was missing. To better focus on the origami-making process, we introduced the hands as an additional element.

MG: What is the strangest thing that has ever happened to either of you while producing a project?

MK: I had to re-edit a commercial spot after it had been running for over two weeks because it displayed the word "God" for about two frames. Apparently, someone with far too much time on their hands had watched the spot frame by frame and complained. That's when I learned you can't use the word "God" in a commercial to sell skater fashion.

WARN1N6:
DØ NØT TH1NK DUR1N6 TH1S R3F1LL. TH1NK1N6 NØW
MAY CAUS3 S3R1ØU$ W3ALTH DAMA63! 1N CAS3 OF
ACC1D3NT 6Ø TØ ØP1N1ØN CARTR1D63 1MM3D1AT3LY.

Project Title: Suk&Koch Demo Reel
Project Type: Self Promotion
Channel/Venue: Demo Reel
Director, Producer, Sound, Music, Design: Suk&Koch
Actor: Kim Min

Thomas Chou / Channel [V] / Hong Kong, China

Like many motion graphic designers, Thomas Chou gets around. After studying a film and video degree at the University of Texas, he jumped at the chance to work on a graphics project in Taiwan. From there, it was only a short leap to Hong Kong and MTV Asia. Although Chou now works extensively with Channel [V], he is also a partner and founding member of Da Joint, a creative firm based in Hong Kong. The other partners of Da Joint are Chan Ka Hing, Yung Kwok Yin, and Ken Ng.

Melanie Goux: The show opening you produced for Rave Traveler features live action elements, captured mid-motion. The footage is then "scrubbed" or "rocked" back and forth to nice effect. Was the thought to play with the idea of "coming and going" or was it more of an expression of movement?

Thomas Chou: I had seen the technique used before and liked the execution very much. It lends itself well to dramatizing the action without completely freezing the motion. I was looking for a way to capture a "natural posing" that could somehow sustain a loose narrative, and so I decided to make use of this technique. We shot the project on film and therefore it was relatively simple to achieve this technique through the film to videotape transfer process. This approach was also very efficient since we only needed to shoot a very limited amount of film.

MG: For a number of years, you've worked on a free-lance basis for Channel [V]. Do you often work alone or as part of a larger team? For example, how was the concept for Rave Traveler developed?

TC: Chan Ka Hing, Creative Director at Channel [V], briefed me on the project, and we developed the concept together. Although it varies from project to project, I mostly work directly with Chan Ka Hing.

Project Title: Rave Traveler
Project Type: Program Open
Channel/Venue: Channel [V], Greater China
Producer: Thomas Chou
Creative Director: Chan Ka Hing
Executive Creative Director: Rob Middleton
Software: Adobe AfterEffects, Adobe Photoshop, Elastic Reality
Hardware: G4 Macintosh

MG: The Very China show opening uses traditional Chinese paintings as animated backdrops for contemporary live action of people and objects. The first time I saw this piece, I loved it. Tell us a little about how it was produced.

TC: The Very China open was inspired by the work of photographer Miro Svolik. I had seen a series of his photographs with small human subjects placed over simple, graphic backgrounds. I realized immediately that the composition of these photos was very similar to that of traditional Chinese paintings. Also similar were the small figures placed within larger environments. From there, I searched for and eventually found more traditional Chinese

watercolor paintings with similar compositions. Those served as our reference for the shoot.

I shot the kids using a Sony BetaCam video camera, using only slight camera motion. I then composited or layered these images over some dissolving brush backgrounds created by the artist Tsai Yi Yuan. He is known for working in oil and traditional watercolor. We shot the paintings as he created them. Later, we digitally removed his hand and brush.

But above all, Very China owes a debt to Ryuichi Sakamoto's music. Being a music channel, we were fortunate to be able to use his music. It inspired us and I believe it breathes life into the piece.

MG: Do you often rely on traditional art for inspiration?

TC: I do not do it often enough. I think traditional art and design has more to offer than we are sometimes willing to admit, especially in this part of the world. But sometimes, when we are too familiar, it is difficult to see things from a new perspective. For this project, it was a pleasure to acknowledge these traditional works by blending images of old and new China together.

Project Title: Very China
Project Type: Program Open
Channel/Venue: Channel [V], Greater China
Producer: Thomas Chou
Creative Director: Chan Ka Hing
Executive Creative Director: Rob Middleton
Software: Adobe AfterEffects, Adobe Photoshop
Hardware: G4 Macintosh

5.

>resources

>tutorial

>glossary

>acknowledgments

tutorial > basic video transitions

At the core of motion graphic design lies the transition. Transition techniques may range from basic cuts and dissolves, to more complex segues involving multiple effects and layers. The most successful transitions aren't necessarily those involving the greatest time and effort to create. Instead, transitions that mesh seamlessly within the body of a larger piece and are appropriate to the tone, pace, music, and look of the composition are by far the most effective.

The following examples illustrate a very basic set of transition techniques. More complex transitions are often derived through combining two or more of these simple techniques in unique ways. Although transition options will vary slightly depending on the capabilities of each production environment, these simple segues are possible in a multitude of formats and production settings.

Transitions covered in this tutorial:

>push	>overlay: composite
>slide	>overlay: straight video
>wipe	>endless pan
>wipe key	>cosmic zoom
>flare	>pageturn
>glow	>splash
>mosaic	>moving matte

 push & slide

>push

SOURCE A SOURCE B

In this example, the Push transition is indicated by a black-and-white dotted line.

The primary difference between a Push and Slide transition is in the motion, or lack thereof, of the first
or underlying clip. In a Push transition, the motion of Source A is essentially "locked" to that of Source
B (incoming frame), which appears to Push Source A off the screen. Push and Slide transitions are
often used in live production settings or whenever more traditional video effects are available. Many
Digital Video Effect (DVE) devices have the ability to perform these effects as pre-programed functions.

>slide

SOURCE A SOURCE B

In this example, the Slide transition is indicated by a black-and-white dotted line.

Notice how the position of Source A does not change. The only motion here is that of the incoming clip
(Source B), which appears to Slide in and overtake Source A. In addition to DVE devices, most Character
Generators are capable of these, and other, basic effects. When entering into a new production
environment, it's advisable to familiarize yourself with all the capabilities of each device available for
production. There will occasionally be situations, such as live broadcast, where these basic effects are
the only tools available to the motion graphic designer.

 # wipe & wipe key

>wipe

SOURCE A SOURCE B

In this example, the Wipe transition is indicated by a black-and-white dotted line.

Wipe transitions are perhaps the most common transitions available in television production. Even the most basic video switchers and mixers come equipped with standard wipe patterns, which are used to electronically transition between two or more video sources. Wipe patterns may be hard-edged or soft, include borders and edges, modulated (varied in shape), or in a fixed geometric pattern. The range of Wipe patterns varies with each device, but generally consists of variations of geometric shapes such as circles, stars, rectangles, etc.

In Wipe transitions, the source video is not effected or animated beyond being revealed or obscured by the Wipe transition. Wipes themselves are not visible to the viewer, only the result of their action is visible. Wipe transitions are often used in live production settings or whenever more traditional video effects are available.

>wipe key

SOURCE A SOURCE B

In this example, the Wipe Key transition is indicated by the $ symbol.

Similar to Wipes from video switchers and mixers, the Wipe Key may consist of any two-dimensional shape. Although some video switchers and mixers are capable of accepting customized patterns and shapes, many are not. Therefore, Wipe Keys are most often produced through the use of graphics production software such as Adobe AfterEffects.

Most Wipe Keys rely only on the Alpha Channel information of the Wipe source to transition between one or more additional video sources. Therefore, any picture information, such as color or texture, assigned to the Wipe Key source will go unseen. Shown here, the $ symbol was created in Adobe Illustrator and imported into Adobe AfterEffects. The green, or "money" layer was imported into the composition first, the orange, or "consumer" layer was placed above or given a higher priority. Then, the $ symbol was imported and animated in Z axis. The last step was to select the $ symbol layer as the Track Matte source for the orange or "consumer" layer.

Wipe Keys may also be referred to as Moving Mattes, Matte Keys, or Hole Cutters.

 # flare, glow & mosaic

>flare

SOURCE A SOURCE B

In this transition, the Flare was produced using a standard lens flare in Adobe AfterEffects, which was applied to both sources A and B.

This transition uses a video effect to seamlessly blend two or more sources into a more unified presentation. The two sources (A and B) are cut or dissolved between, near or at the peak of the Flare effect. The result is a more dramatic and visually interesting segue than would be possible with a cut or dissolve alone. The effect begins with the Flare settings applied at minimum levels, peaks with Flare settings reaching maximum brightness and resolves with settings returning to minimum. For added interest, the center position and spread of the Flare may be animated over the duration of the transition.

>glow

SOURCE A SOURCE B

In this transition, the Glow was produced using the standard glow filter in Adobe AfterEffects, which was applied equally to both sources A and B.

Similar to the Flare transition above, this sequence begins with the Glow effect settings applied at minimum levels, peaks with Glow settings reaching maximum brightness, and resolves with settings returning to minimum. The two sources (A and B) are cut or dissolved between at the peak of the Glow effect. This transition works particularly well with sources containing large areas of bright color or white. Since the Glow effect reacts to the lighter values of a picture, this transition is slightly more difficult to control than the Flare transition mentioned above.

>mosaic

SOURCE A SOURCE B

In this transition, the Mosaic effect was produced using the standard mosaic filter in Adobe AfterEffects, which was applied equally to both sources A and B.

Almost any video effect will serve to create a smoother transition if applied equally across both A and B sources. Although new effects are made possible through the availability of third party plug-ins, the basic theory of effect transitions remains the same.

overlay

>overlay: composite

SOURCE A SOURCE B

To produce an Overlay transition, an additional (third) source is required for use as the Overlay.

In place of a video effect applied directly to sources A and B, overlay transitions use a third moving source, dissolved or keyed in, over the transition point of sources A and B. In other words, the two sources (A and B) are simply cut or dissolved between, near or at the peak opacity of the overlay (third) source.

The Overlay source used in this example is nothing more than lights of cars, shot at night with a Sony DV-Cam set to a very slow shutter speed. Overlay sources are most effective when they bear some relation to the video they bridge. For the purposes of this tutorial, we have attempted to clearly distinguish the Overlay source from sources A and B.

In this example the Overlay source is both luminance keyed and dissolved in over sources A and B. The result is a slightly softer and more integrated transition than would be produced by simply dissolving in the Overlay source alone.

>overlay: straight video

SOURCE A SOURCE B

Shown here is the straight source video used to create the Overlay Composite example above. We chose the brightest part of the videoclip to appear directly at the center (peak point) of the Overlay transition. Because the video is very high contrast, we were also able to luminance key the Overlay to create a slightly smoother effect.

Almost any interesting video will serve to create an Overlay transition, provided the video is compatible with sources A and B and suits the pace or rate of the transition. Another popular and effective Overlay device is that of a flag or drape of fabric passing in front of the screen. Unlike the example above, the Overlay source used for such a transition must begin and end off screen, with at least one completely opaque frame in the center to obscure the cut between sources A and B.

endless pan & cosmic zoom

>endless pan

Transitions between individual segments are denoted by the black-and-white bars at top and bottom of the screengrabs above.

An Endless Pan is one in which video, graphics or both, are animated to pan from left to right, or right to left across the screen, as if in a seamless parade. Although most desktop graphics software is not limited to the size of images it can import and manipulate, standard definition video incorporated into these compositions is always a fixed size. As a technique for working with standard definition video, or simply as another approach to motion, there is the Endless Pan.

The trick to producing endless pans is to animate all segments with linear motion, without spline curves. Linear motion maintains uniform speed throughout the move, making subsequent frames easy to match. To create the illusion of depth, foreground layers (those closest to the viewer) may be animated at a faster rate. Endless Pans animated using systems capable of perspective (Z depth) will appear even more realistic.

>cosmic zoom

| CLIP A | CLIP B | CLIP B | CLIP B & C | CLIP C & A | CLIP C & A |

A Cosmic Zoom is an animation technique used to create the illusion of traveling incredible or imaginary distances in Z space (depth).

In simple terms, Cosmic Zooms are a series of zooms (Z motion), composited so as to appear as a seamless voyage. Some Cosmic Zooms may appear very realistic, with perfectly matched segments, and carefully choreographed footage. However, simple Cosmic Zooms, such as the one above, may also be employed to good effect.

In this example, we have started and ended with the same frame to better illustrate the theory of Cosmic Zooms. We have made little or no effort to perfectly match the various segments, yet the effect is still visually interesting. To create this effect, we animated three clips: segments A, B and C with Z motion that was identical in distance and duration. Once animated, the three segments were layered or composited over one another in the desired hierarchy.

 # pageturn, splash & moving matte

>pageturn

SOURCE A SOURCE B

A Pageturn is a standard video transition possible with most desktop production software and/or DVE devices. Such an effect, when used appropriately (in this case a Pageturn for a show about books), is a simple but effective transition device. One advantage of employing such a standard effect in your projects is they may also be utilized within program content. In this case, the Pageturn effect was also used within the program to indicate the transition from one guest to the next.

>splash

The Splash in this example is provided by the red dot.

Splash transitions are an easy and dramatic way to reveal logo or show titles that traditionally appear at the beginning or end of opening title sequences. Splash transitions may be created from any element or elements desired. For best effect, Flash transitions should be very fast, (no more than twenty to twenty-five frames in duration) and animate with smooth or spline motion so as to ease down into position.

>moving matte

The Moving Matte in this example is provided by a video clip of a brush painting of black ink onto white paper.

By assigning the brush clip as the Moving Matte source for the sky footage, we've achieved the transition above. Virtually any high-contrast video or graphic source may be employed as a Moving Matte. For complete transitions, the Moving Matte should begin in complete black or white and end in the reverse luminance value. Color video may also be utilized as Moving Mattes, provided the image is of sufficient contrast.

glossary

3:2 pull-down
Method used to map the 24 fps of film onto the 30 fps (60 fields) of NTSC video, so that one frame of film occupies three video fields, the next occupies two fields, etc. Two fields of every other video frame originate from different film frames which makes precise Rotoscoping and Editing difficult.

4:3
Aspect ratio of the NTSC TV screen, which is four units wide and three units tall, proportionally, regardless of the actual size of the screen.

16:9
Aspect ratio of widescreen DTV formats for all HDTV and some SDTV (Standard Definition) video. The aspect is 16 units wide and 9 units tall, proportionally, regardless of the actual size of the screen.

A

A-B roll
Videotape editing arrangement in which scenes are played alternately from sources A and B and recorded on C. Typically, the final output recorded on C contains some scenes from A and some from B, edited with transitions, (cuts, mixes, wipes etc.) between the scenes.

Accom
US manufacturer of professional digital video equipment such as Digital Disk Recorders (DDR), Digital Video Effects (DVE), and editing systems. For more information about the company, including the current product line: http://www.accom.com

Additive Mix
Addition of two video images together without attenuation of either signal.

AfterEffects (AE)
Desktop software marketed by Adobe Corp. that enables layering and application of effects to digital video. Because of its relatively low price and ease of use, AfterEffects has become the software of choice for professional and amateur motion graphic designers alike. See also Cosa. For more information: http://www.adobe.com/motion/main.html

Air
To broadcast a signal.

Aliasing, Spatial
Undesirable artifacts in the picture caused by a low sampling rate or poor filtering. Usually revealed as stair steps in diagonal lines. See also Anti-Aliasing.

Aliasing, Temporal
Undesirable motion artifacts such as wagon wheel spokes appearing to reverse. Any motion artifact that results from a video standards conversion with insufficient temporal filtering.

Aliens
Industry jargon for any undesired artifact, spatial, temporal, or aural.

Alpha Channel
The fourth channel of an RGB image. The Alpha Channel serves to define the shape and transparency levels of the composite image. Sometimes also referred to as Matte, Hole Cutter, or Key Signal.

Anamorphic
The change of a wider aspect ratio to a narrower ratio or vice versa. Anamorphic lenses are used to change the proportions of an image by either extending the horizontal axis or compressing the vertical.

Animation
A sequence of still images or artwork recorded on sequential frames of video or film. The frames may flow together smoothly to create a sense of motion or appear abrupt and disconnected.

Anti-Aliasing
Blending around the edges of images or text that serves to make edges appear smooth when viewed on-screen.

Aspect Ratio
The ratio of the width relative to the height of a picture. For example, the aspect ratio of standard definition NTSC video is 4:3 and that of High Definition Television (HDTV) is 16:9. There is another way to express aspect ratio. The aspect ratio of standard definition NTSC video may also be described in decimals as 1.33, (this number is derived by dividing 4 by 3). Hence, the decimal aspect ratio of HDTV is 1.78. The film community has many more aspect ratios to consider when working and so has generally adopted the decimal system to describe the shape of pictures. For a more complete description of Aspect Ratios, see The Quantel Digital Factbook online: http://www.quantel.com/domisphere/infopool.nsf/html/dfb

Avid
A line of software based, offline and online editing system that may include additional transition, layering, and effect capabilities. For more information on the complete Avid product line: http://www.avid.com

Axis (X, Y, Z)
A means to describe three-dimensional space and objects for the purposes of object and/or camera animation. The X, Y, and Z Axes are always set at right angles to each other. In the simplest terms, the X Axis spans across the object or screen, left to right, (horizontal). The Y Axis spans from top to bottom of object or screen, (vertical). The Z Axis refers to depth.

B

Bandwidth
The complete range of frequencies over which a circuit or electronic system can function with minimal signal loss, typically less than 3 decibels. Also used to refer to the information-carrying capability of a particular distribution channel.

Beauty
In compositing, the visible part of an image that fills the hole or shape provided by a matte or key signal.

Betacam
An analog video taping system using a 1/2-inch tape cassette, developed by Sony. Digital versions include Digital Betacam and Betacam SX.

Black Level
The light level at which a video signal representing picture black is reproduced on the displayed video image.

Blue Screen
A process by which a subject is recorded in front of a blue screen and the resulting image is then modified, either optically or electronically, to replace any blue areas of the picture with another image such as location footage, etc. Although the process is similar in effect to chroma key, Blue Screen generally refers to the optical process used in film production.

Broadband
Transmission methods capable of handling frequencies greater than those required for high-grade voice communications.

Broadcast Designer's Association (BDA)
Founded in the USA in the late 1970s to help promote the recognition of broadcast design. For more information about BDA, including how to become a member, see: http://www.bda.tv

Broadcast Quality
In the USA, this is a quality standard for video signals set by the

NTSC and conforming to FCC rules. Generally speaking, for a program to be considered broadcast quality, it must conform to the technical specifications appropriate to the country or region in which it will be broadcast. To view a map of world video standards, see: http://www.video-pro.co.uk/worldtv/index.html

Bumper
Short clips of animation which are broadcast at the end of a program segment, but before a commercial, or at the beginning of a program segment, but after a commercial. These elements effectively create a bumper between programs and commercial spots.

C

Cell Animation
The process of creating single frames intended to be recorded and played back in sequence. Usually refers to the process of hand drawing, or otherwise manipulating images in single frame increments. See also Rotoscoping.

Character Generator (CG)
A device or software application used for creating text on screen. Most often used for: crawls, rolls, tickers, supers, and other type displays for television. Character Generators are used extensively in television news and sports broadcast for all on-screen type displays. Although numerous companies market Character Generators, the device, as well as the process of applying on-screen type, is sometimes generically referred to as "adding Chyron."

Chroma
The color information in a video signal that comprises the hue (phase angle) and saturation (amplitude) of the color subcarrier signal.

Chroma Key
A video effect wherein a particular area of color, (most often one of the RGB component colors) is removed from a video signal and replaced with a different signal. This effect is often used during newscasts to insert a weather map behind the on-screen presenter. The process is similar in effect, but not in practice, to Blue Screen techniques used in film production.

Chrominance
The amount of color or the saturation of color in a picture.

Chyron
Manufacturer of professional video equipment, most notably Character Generators. For more information about the current line of Chyron products, see: http://www.chyron.com

Clip
In keying, the range of a key source signal at which the key or insert takes place. The control that sets this action is also referred to as a Clip. In production, the term Clip is used to describe a piece of digitized video or audio that serves as source material for editing.

Clone
An exact digital copy, indistinguishable from the original.

CODEC
Compression/decompression algorithm. A protocol used to encode and decode, or compress and decompress data including sound and video files. Common CODECS include MPEG-2 and QuickTime.

Color Bars
A video test signal widely used for system and monitor setup. Contains bands of color with fixed amplitudes and saturation.

Color Space
The color range between specified references. Typically references are quoted in television: RGB, Y, R-Y, B-Y, YIQ, YUV and Hue Saturation and Luminance (HSL). In printing, Cyan, Magenta, Yellow and Black (CMYK) are used. Converting pictures from one Color Space to another requires careful attention. Working across media, ie television to print, always requires conversions in color space.

Component (Video)
The normal interpretation of a Component Video signal is one in which the luminance and chrominance remain as separate components. Component Video signals retain maximum luminance and chrominance bandwidth.

Composite (Video)
A video signal in which the luminance, chrominance, and timing reference have been combined according to the coding standards of NTSC, PAL or SECAM. The process, which is an analog form of video compression, restricts the bandwidths (image detail) of components.

Compositing
Simultaneous multi-layering of moving and still pictures. Motion graphic design often employs this sort of multi-layering to create complex animations and effects. See also Layering.

Compression Ratio
The ratio of the size of data in the non-compressed digital video signal to the compressed version.

Compression (Video)
The process of reducing the bandwidth or data rate of a video stream.

Computer Graphic Imagery (CGI)
Any image produced entirely by means of software, ie non-photographic, digitally produced images. Also referred to as synthetic imagery.

Cosa
Original developers of AfterEffects software. Cosa AfterEffects v.1.0 first shipped in January 1993. In July of the same year, the company was purchased by Aldus which later merged with Adobe Corp. Some early users of AE will occasionally refer to the software as Cosa.

Crawl
Text or images that move horizontally, either left to right or right to left, across the screen. See also Roll, Ticker.

Cut
A hard transition or edit from one video or audio source to another. In a Cut, video and/or audio sources change abruptly from one frame of film or video to the next. See also Dissolve.

D

D1
A component digital video recording format that uses data conforming to the ITU-R BT.601-2 (CCIR-601) standard. The term is used generically to indicate component digital video.

Digital Betacam (Digi-Beta)
A video tape machine, developed by Sony, that records digitally on 1/2-inch video cassettes. Not to be confused with Betacam, the analog precursor to Digital Betacam, also developed by Sony. The term Digital Betacam may refer to the tape cassettes utilized by Digital Betacam machines and/or the machines themselves.

Digital Cinema
Refers to the digital distribution and projection of cinema material. Advantages of Digital Cinema include the lack of traditional film defects such as scratches and film weave—even after many showings. Besides quality issues, Digital Cinema introduces potential new methods for duplication and distribution, possibly by satellite, as well as flexibility in screening.

Digital Disk Recorder (DDR)

Disk drives that record and play sequential frames of digital video. They are often used as a replacement for video tape recorders, or as video caches to provide extra digital video sources. The first version of a Digital Disk Recorder was developed in the USA at Ampex in 1976 by a talented team of engineers including a young Junaid Sheikh. This system was named Electronic Still Store (ESS) and was capable of performing real-time record and playback of sequential frames of video. However, this capability was never completely utilized, since the ESS was marketed primarily as a slide projector replacement for television stations. Junaid Sheikh would later go on to found a company named Abacus, which in 1984 introduced the first Digital Disk Recorder designed specifically for editing and computer graphic applications.

Digital Television (DTV)

Often used to describe one of the many new forms of terrestrial transmission of video program material.

Digital Video (DV)

A digital video recording and playback format that is a co-operation between Hitachi, JVC, Sony, Matsushita, Mitsubishi, Philips, Sanyo, Sharp, Thomson, and Toshiba. It uses 1/4-inch wide tape in a range of products to record 525/60 or 625/50 video for the consumer (DV) and (Panasonic's DVCPRO and Sony's DVCAM) for the professional markets.

Digital Video Effects (DVE)

Any device that enables the manipulation of a video image across the X, Y, and/or Z axis in real time. Because most DVE devices interpret the video image as a flat plane, the effect is often one of a flat image floating in three-dimensional space. For this reason, animation produced using a DVE is sometimes referred to as 2 1/2 D or 2.5D.

Discreet

Creators of high end (primarily software based) tools used extensively in professional video and film production. The current product line includes software such as Flame, Inferno, and Combustion, to name a few. For more information about Discreet: http://www.discreet.com

Dissolve

A soft or gradual transition that blends one audio or video source into another. Sometimes referred to as a cross-fade, Dissolves may be as fast as two frames or infinitely slower, but always involve a mixing of sources prior to completion of transition. Dissolve transitions are sometimes referred to as cross fades. See also Fade.

Drop-out

The area of a magnetic tape or a digital disk recorder where information is missing from the recorded image. Drop-out may occur due to dust, lack of oxide (video tape only), or other equipment malfunction.

Dub

A copy of an existing tape. To make a copy of an existing tape.

DVCam

A digital video and audio recording format, based on a joint manufacturer-developed CODEC for hardware and/or software.

DVTR

Digital videotape recorder.

E

Edit

The process of determining the order and duration of source video or audio footage in order to create a finished program, commercial spot.

Editorial

Generally refers to programs, rather than commercial spots or graphic packaging.

Effect

Any manipulation of a frame or frames of video to change its appearance.

ENG

Electronic News Gathering. Term applied to a small portable outfit, with a broadcast quality TV camera, VTR, and/or microwave link, usually used for news.

Enhanced TV

Term used by the Public Broadcasting System (USA) for certain digital on-air programing (usually educational) that includes additional resources downloaded to viewers. Some forms of Enhanced TV allow live interaction; other forms are not visible on-screen until later recalled by viewers. Also known as "datacasting."

F

Fade

A gradual transition from a video source to a solid color, such as black or white, or vice versa. A soft transition from video to color is known as a Fade down. A soft transition from color to video is known as a Fade up. Soft mix transitions from one video or audio source to another are sometimes referred to as cross Fades. The term Fade is appropriate to describe both video and audio transitions of this type.

Fart Frame

Those interesting, but unexpected frames that often pop up during video production.

FCC

Federal Communications Commission. This is the independent, US government agency, directly responsible to Congress. The FCC was established by the Communications Act of 1934 and is charged with regulating interstate and international communications by radio, television, wire, satellite, and cable. The FCC's jurisdiction covers the 50 states, the District of Columbia, and US territories. For more information about the FCC: http://www.fcc.gov

Field

One-half of a frame or complete video picture. A complete television frame consist of two Fields; the lines of Field 1 are vertically interlaced with those of Field 2, resulting in 525 lines of resolution according to the NTSC standard. Animation rendered or interpolated in Fields will always appear to move more smoothly than animation rendered in frames.

Flame

Digital compositing software from Discreet. Flame is used in the production of multi-layered effects and graphics for commercial spots, music videos, feature films, show openings, broadcast promos, etc. See also Inferno. For more information about the Discreet product line: http://www.discreet.com

FPS

The number of frames per second captured during recording or displayed during playback. Sometimes referred to as temporal resolution. See also Frame Rate.

Frame

In film or video, a Frame is one complete picture. A complete Frame of video consist of two fields; the lines of field 1 are vertically interlaced with those of field 2, resulting in 525 lines of resolution according to the NTSC standard.

Frame Rate

The number of frames per second captured during recording or displayed during playback. Sometimes referred to as temporal resolution. See also FPS.

Freeze Frame
See Still Frame.

G

Generation Loss
The signal degradation caused by successive recordings. Generation Loss does not generally occur when copying digital video and audio unless it is repeatedly compressed and decompressed. See also Generations.

Generations
The number of times a video or audio clip is copied. A clip that has suffered substantial quality loss is said to have "gone down too many generations." Generation loss primarily affects analog recordings. See also Generation Loss.

H

Hal
See Quantel.

Harriet
Dedicated device used in the design and animation of motion graphics, developed by Quantel.

Henry
See Quantel.

High Definition Television (HDTV)
Not to be confused with Standard Definition Television (SDTV). HDTV has a screen aspect ratio of 16:9 and twice the resolution in pixels of SDTV.

Hole Cutter
Also referred to as matte, alpha channel or key signal. Basically the fourth or unseen channel of a video picture that defines the visible area of the image. Alpha channels are used in video production, but are not transmitted.

HSL
Abbreviation of Hue, Saturation, and Luminance.

Hue
(1) The distinction between colors (eg, red, yellow, blue, etc.). White, black, and gray tones are not considered hues. (2) The color tint of a video image. Sometimes referred to as Phase.

I

Illegal Colors
Colors which fall outside the range of a specified video format or standard in luminance or chrominance. Illegal colors within a video signal cannot be successfully recorded and/or transmitted. Although Illegal Colors are of greater concern in analog recording and transmission, use of these "hot" colors will often result in technical problems for digital video as well. Vectorscopes, waveform monitors and other video diagnostic devices may be used to warn of possible "out of gamut" colors. Although standards vary slightly, safe colors, or those not considered illegal in NTSC television, must be above 7.5 and below 100 IRE units in luminance and below 105 IRE units in chrominance.

Industrials
Projects specifically designed, written, and produced for in-house viewing by companies or groups.

Inferno
Discreet's premier visual effects system that supports all resolutions from film and video to DTV/HDTV. Inferno software is used extensively for professional video and film production (primarily, but not limited to motion graphic design and animation). See also Flame. For more information about Discreet: http://www.discreet.com

Institute of Radio Engineers (IRE)
Standard unit of measurement dividing the area from the bottom of sync to peak white level into 140 equal units. 140 IRE equals 1 volt peak-to-peak. The range of active video is 100 IRE.

Interlacing
The system developed for early television and still used in SDTV that weaves or interlaces the scanlines from field 1 vertically between those of field 2 to create a single frame of video. The process of interlacing allows for the display of fewer scanlines at a higher temporal rate. See also Field.

Interpolation (Spatial)
Defining the value of a pixel from those surrounding it.

Interpolation (Temporal)
Interpolation between the same point in space (pixel) on successive frames.

Interstitial
Generally refers to any animated element in broadcast television that carries branding and/or promotional information such as upcoming programs. Interstitial elements are not commercial spots, programs or newscasts. In other words, they are considered packaging, not content.

IOD
Information on Demand. Industry jargon for text such as sports scores, weather temperatures, traffic information etc., positioned in the lower third of the television screen. IOD elements may be still or moving.

J

Japaneseum
Anything Sony. Products and software with cute, well designed, functional and/or user-friendly qualities which seem to have been perfected only by the Japanese.

JPEG
Joint Photographic Experts Group, the original name of the committee that wrote the image compression standard. JPEG is best suited for compressing either full-color or gray-scale images.

K

Keyframe
A set of parameters defining a location in space or effect settings of a video source. Digital effects must have a minimum of two Keyframes, start and finish, to be implemented, although more complex moves and effects might use many more.

Keyframing
The process of creating effects that change over time by selecting a beginning setting and an ending setting that results in the software automatically generating frames in between. Also refers to position keyframes in animation whereby a starting and ending position for an element are selected and the software derives all intermediate positions. More and more parameters are becoming "keyframeable," meaning they can be programed to transition between two, or more, states.

Keying
To replace part of a television image with video from another image. There are many different types of keys and Keying may occur by numerous methods. There are luminance keys, which select only the brightest or darkest parts of an image. There are matte keys, which involve an additional source used as a key signal or hole cutter.

And there are chroma keys, which only select out a particular hue for replacement. These are just a few of the many variations of keys. See also Chroma Key, Blue Screen.

Key Signal
The fourth channel of a 32-bit RGB image. The Key Signal serves to define the shape and transparency levels of the composite image. Also referred to as Matte, Hole Cutter, or Alpha Channel.

L

Layer(ing)
Layers are single sources of still or moving video. The process of Layering in animation involves creating a hierarchy of sources that are then composited to create a finished piece of motion graphics. Layers that will appear in the foreground of a composition will generally require a matte or alpha channel to be seen. Most motion graphics software and hardware systems now allow for the compositing of many layers simultaneously.

Letterbox
Displaying a wider screen image on a conventional 4:3 display by reducing the image within the smaller aspect. Due to the difference in aspects, unused areas at the top and bottom of the 4:3 screen are often left black. To Letterbox a source for graphic effect involves placing bands of black, color, or another video source at the top and bottom of the screen.

Looping
Continuously repeating a clip segment of video or audio from point A to point B. Loops may be used to create the effect of continuous play or rock backwards and forwards as desired.

Luma Matte
A black-and-white image which serves either as a key signal for video or as a source or hole cutter for a wipe transition.

Luminance
The black and white, or brightness level of a component video signal. Also called the "Y" signal.

M

Matte
A separate still or moving video source that is generally, but not always, black-and-white. Mattes are used for the purpose of masking or redefining the shape of the primary video source. When utilized in production, Mattes are invisible to the end viewer and function primarily to reveal other video sources. When beauty and mattes are joined, ie originate from the same source, the matte is then referred to as the alpha channel or key signal. See also Beauty, Key Signal.

MBG
Moving background.

Metadata
Data about data. Data about the video, not the video bits themselves. It is increasingly believed that Metadata will revolutionize every aspect of video production and distribution.

MPEG
Moving Picture Experts Group. A group of standards for compressing moving pictures. For more information on all the MPEG video and audio standards, see: http://mpeg.telecomitalialab.com

N

Non-linear Editing
Editing that is performed in a non-linear sequence, or not necessarily in the sequence of the final program. Non-linear Editing offers quick access to source clips and record space and usually relies on computer disks to store footage. The term is widely used in association with offline editing systems.

National Television Systems Committee (NTSC)
The name of the TV and video standard used in the US, Canada, Mexico, Central America, parts of South America, and Japan. The standard consists of 525 horizontal lines at a field rate of 60 fields per second. Two fields equals one complete frame. Only 486 lines are used for picture. The remaining lines form video blanking and are used to carry sync and extra information such as Vertical Interval Timecode (VITC) and Closed Captioning. Other world TV standards include PAL, PAL-M, PAL-N, and SECAM. To view a map of world video standards, see: http://www.video-pro.co.uk/worldtv/index.html

O

Offline (Editing)
Editing that utilizes lower-cost equipment to produce an Edit Decision List (EDL) and/or a rough cut which can then be conformed in a high quality online suite. Offline editing reduces decision-making time in the more expensive online environment.

Online (Editing)
Production of the complete, final edit performed at full program quality.

OTS
Abbreviation of Over the Shoulder. Refers to those graphics, most commonly used during newscasts, which appear over the shoulder of the news presenter. Also referred to as OTS box, box graphic and/or insert.

Overscan
The active image area in a video picture that is outside the edges of the display device. Television and graphics producers should be aware that image information near the outside edges might not be seen by viewers. See also Safe Title Area and Safe Action Area.

P

Paintbox
See Quantel.

PAL
Phase Alternating Line. The name of the television and video standard currently used in Europe, China, India, Australia, New Zealand, and most of the African continent. To view a map of world video standards, see: http://www.video-pro.co.uk/worldtv/index.html

Pan
Moving the camera horizontally left to right or right to left.

Pan and Scan
The technique used to crop a widescreen picture to conventional 4:3 television ratio, while panning the original image to follow the on-screen action. Pan and Scan transfers are the alternative to letterbox programs for conventional 4:3 television but always result in eliminating much of the original picture.

Phase
In video production, Phase usually refers to the relationship of hue components to one another. Colors which are shifted in hue, or appear unnatural, are said to be "out of phase." See also Vectorscope.

Pixel
Short for Picture Element or Picture Cell. The basic unit from which a video or computer picture is made. A dot with a given hue, saturation and brightness value.

Plug-in
A software addendum, generally produced and marketed by a "third party," designed to work with and enhance the capability of existing desktop graphics software.

Post-Production
The final stage of producing a film or video project during which footage is edited and assembled and effects, graphics, titles, and sound are added.

Post-Production House
Also referred to as Post Houses, these businesses specialize in providing equipment and expertise to program producers. Post Houses generally charge hourly for services such as editing, dubbing, color correction, film to tape transfers etc. They are often able to provide every service a program producer might require to create a finished commercial spot or program.

Pre-Production
The planning phase of a film or video project, usually completed prior to production. Well, at least that's the theory.

Progressive
Short for Progressive Scanning. A system of video scanning whereby lines of a picture are transmitted consecutively, such as in computer monitors. See also Interlacing.

Prosumer
Any software or hardware marketed and sold to the public which has been adopted for use in professional video production. Adobe AfterEffects and Photoshop are examples of Prosumer software.

Q

Quantel
British manufacturers of professional television equipment. The name is abbreviated from Quantised Television. In 1981 Quantel launched one of the first commercially available electronic paint systems, known as the Paintbox. The device revolutionized the look of television and was one of the first tools created specifically for use by broadcast designers. From there, the product line expanded to include motion graphic design systems such as Harry, Henry, and Hal. For a complete history of the company, as well as the current product line, see: http://www.quantel.com

R

RAID
Redundant Array of Independent Disks. A grouping of standard disk drives together with a RAID controller to create storage that acts as one disk. Primarily designed for operation with computers, RAIDs offer very high capacities and fast data transfer rates.

Raster
The entire video display area, including that which is outside the safe title area.

Real Time
In video, Real Time refers to a playback and record rate that occurs at normal or lifelike speed. Effects and transitions applied without interrupting playback or recording are referred to as Real Time effects. See also Rendering.

Rendering
The process of non-real time imaging of a picture that relies on computer processing speed. Render times may increase dramatically according to software, image size and/or complexity of effects. Although devices such as Discreet Logic's Inferno render very quickly, any device which must render prior to output is not considered a real-time device.

Resolution
The amount of information in each frame of video. Generally, the higher the Resolution, the greater the visible detail and the larger the image size. The term is also used to describe the size of a computer image, usually in pixels.

Resolution Independent
A term used to describe equipment or software that enables production and output in more than one resolution or aspect ratio. Most dedicated television equipment, for example, is designed to operate at a pre-set resolution, most desktop computers are not. The term is used to describe certain formats such as EPS that can be scaled according to display size without a loss in quality.

RGB
Red, Green, Blue. The basic components of the color television system. Also the primary colors of light.

Roll
Text or images animating from screen top to screen bottom or vice versa. See also Crawl, Ticker.

Rotoscoping
The practice of using frames of moving footage as reference for painting animated sequences. Also refers to the practice of frame-by-frame or single frame retouching of sequential video.

S

Safe Action Area
Slightly larger than safe title area, the Safe Action Area amounts to about 90 percent of the total picture area (or approximately 5 percent in from edge of raster). Safe title and Safe Action Areas may be determined by overlaying the video image with a predetermined grid.

Safe Title Area
The area that defines the part of a television picture visible to viewers. In other words, the area of the picture in which it is "safe" to place material one wishes to be seen. Traditionally 10 percent in from edge of raster (or approximately 80 percent of total picture area) has been considered the Safe Title Area. Recently the issue of Safe Title Area has become more problematic due to the variety of aspects and display technologies now available to the viewer.

Saturation
The strength or purity of a color. Saturation represents the amount of gray in proportion to the hue, measured as a percentage from 0 percent (gray) to 100 percent (fully saturated). The color information of a video signal consists of hue (phase angle) and Saturation (amplitude).

Scanline
A single horizontal row of pixels on a video display.

SECAM
Sequential Couleur Avec Mémoire. The television broadcast standard used in France, the Middle East, and most of Eastern Europe. To view a map of world video standards: http://www.video-pro.co.uk/worldtv/index.html

Segue
A synonym for transition. The term segue generally implies a more fluid, rather than abrupt change between one image to another or one audio source to another.

SIGGRAPH (ACM SIGGRAPH)
The Association of Computing Machinery (ACM)'s Special Interest Group on Computer Graphics. For more information about the organization, see: http://www.siggraph.org

Signal-to-Noise Ratio (S/N or SNR)
The ratio of noise to picture signal information—usually expressed in decibels. Digital source equipment is theoretically capable of producing pure, noise-free images, which would have an infinite Signal-to-Noise Ratio.

Spatial Resolution
The number of pixels horizontally and vertically in a digital image.

Spline Curve
In animation, a Spline Curve appears to begin and end slowly, reaching maximum velocity at the center of the event. Linear motion, by contrast, maintains a uniform speed throughout the duration of animation or effect and therefore appears to start and stop abruptly.

Spot
Another name for a television commercial.

Standard Definition Television (SDTV)
A digital television system in which the quality is approximately equivalent to that of analog 525/60 and 625/50 NTSC and PAL systems.

Still Frame
A single frame of video which, by definition, has no motion. Also referred to as a freeze frame or simply as a freeze, still or grab.

Still Store
A dedicated device used in professional television production, the primary function of which is to record and display single frames of video.

Style Frames
Sample frames produced for the purpose of presentation or for use in illustrating graphic standards.

Super
The name given to text that usually appears in the lower-third section of the screen. Supers most often contain the name of the person or persons speaking and/or the location being shown, as well as other pertinent information.

Sweetening
Electronically improving the quality of an audio or video signal by adding effects, adjusting levels, color correction, etc.

Switcher
A device that serves as a central mixer of video source material in a television control room or edit suite. Switchers may also perform effects and transitions such as fades and dissolves as well as Switching incoming channels. Also known as a video Switcher or video mixer, Switchers are critical to the production of live television broadcast as they enable the selection of video sources and transitions between those sources. Switchers operate in real time and do not require rendering.

T

Ticker
Moving displays or crawls of text and numbers that most often move from screen right to screen left, across the bottom of the screen. Tickers may be used to display urgent weather information or breaking news, stock prices and/or sports scores. See also Crawl, Roll.

Tilt
Moving the camera vertically from up to down or down to up.

Time Code
A time reference recorded in conjunction with picture information and used to identify each frame. Time Code is necessary for precise editing and is expressed as follows: H= hours, M= minutes, S= seconds, F= frames

00:00:00:00
H M S F

Transition
The change from one video or audio clip to another. Transitions may be simple cuts or complex, intertwined layers using a variety of effects and source material. For more information on Transitions, see the tutorial section of this book, pp144–151.

U

Underscan
On video monitors, a mode that decreases the raster size horizontally and vertically so all four edges of the picture are visible.

V

Vectorscope
A specialized oscilloscope used to display the color information in a video signal relative to phase. A trademarked name that has become the generic description for a vector display unit that allows visual checking of the phase and amplitude of the color components of a video signal.

Vertical Interval Time Code (VITC pronounced "vitsy")
Vertical Interval Time Code, or Time Code encoded as video inserted into the vertical interval of the video. See also Time Code.

Vision Mixer
See Switcher.

VTR
Video Tape Recorder.

W

Waveform Monitor
A specialized oscilloscope used to display the luminance information in a video signal. Waveform Monitors are useful for, among other things, checking luminance levels of video images.

Widescreen
Term given to picture displays with a wider aspect ratio than NTSC 4:3. Digital HDTV is 16:9 widescreen. Most motion pictures also have a widescreen aspect ratio.

Wipe
A transition from one video source to another, involving a moving shape or pattern. Patterns for Wipes are myriad and range from simple circles or rectangles to elaborate, moving shapes. Wipe transitions are most often generated by switchers in live program production or traditional production environments and are no longer commonly used in graphics production. For more information on Wipes, see the tutorial section of this book, pp144–151.

Y

YUV
A color model used chiefly for video signals in which colors are specified according to their luminance (the Y component) and their hue and saturation (the U and V) components. See also RGB.

Z

Zoom
Enlarging or minimizing an image within the active image area. Also the motion of a picture or object in the Z axis.

Sources:

Grass Valley Group Dictionary of Technical Terms
http://www.thomsongrassvalley.com/docs/Miscellaneous/Dictionary

Quantel Digital Fact Book
http://www.quantel.com/domisphere/infopool.nsf/html/DFB

KCTS TV Tech Glossary
http://www.kcts.org/inside/techreport/resources/glossary.asp

Digital Television Glossary of Terms
http://www.digitaltelevision.com/dtvbook/glossaryf.shtml

Acknowledgments

The authors would like to thank the following individuals or groups for their help, inspiration and/or support in producing this book: Jay Antzakas, Eileen Devine, Michaela Devine Houff, Pattie Belle Hastings, John Copes, R. Elise Tomek, Simone Montalto, Chris Foges, Erica ffrench, and the Broadcast Designer's Association.

No book on motion graphic design would be complete without acknowledging the valuable contributions of the talented people who have created the software and hardware tools we use. Special thanks to: Apple Computer, Adobe Corp., Sony, Cosa, Chyron, Accom, Grass Valley Group, Quantel, Discreet, SGI and countless others too numerous to mention. Thank you for making tools good enough to be taken for granted.